AIRBRUSHING

THE

HUMANFORM

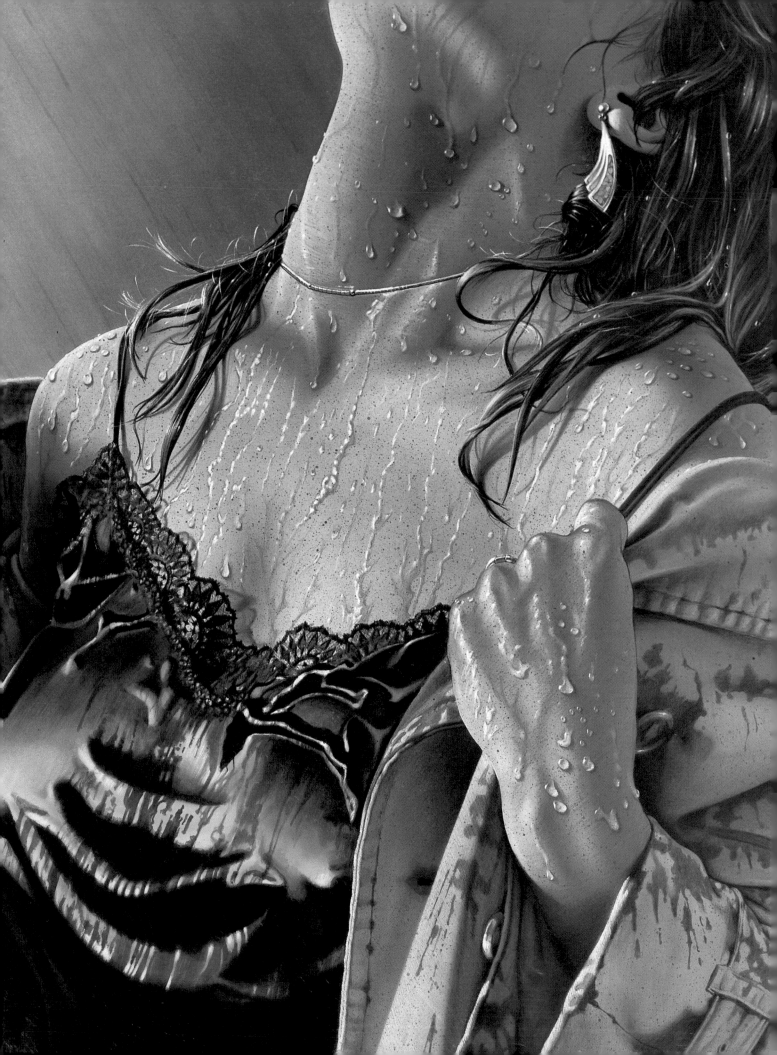

AIRBRUSHING
THE
HUMANFORM

ANDY CHARLESWORTH

Studio
Vista

STUDIO
VISTA

Copyright © Quarto Publishing plc 1988

First published in Great Britain in 1988 by
Studio Vista
An imprint of Cassell Publishers Ltd
Artillery House, Artillery Row
London SW1P 1RT

ISBN 0-289-80004-8

This book was designed and produced by
Quarto Publishing plc
The Old Brewery, 6 Blundell Street
London N7 9BH

Project Editor: Jack Buchan

Editors: Sandy Shepherd and Eleanor Van Zandt
Design Stylist: Bob Cocker
Designer: Graham Davis

Art Director: Moira Clinch
Editorial Director: Carolyn King

Typeset by Burbeck Associates
and QV Typesetting Ltd

Manufactured in Hong Kong
by Regent Publishing Services Ltd

Printed by Leefung-Asco Printers Ltd, Hong Kong

Front cover: David Bull,
commissioned by Y & R Madrid

CONTENTS

INTRODUCTION

Throughout history, mankind has attempted to depict the human form in paintings of various kinds. Indeed, many scholars believe that some of the oldest paintings of all, produced about 15,000 years ago and found in caves in the south-west of France, were produced by a technique broadly similar to airbrushing. On the walls of these caves there are images of human hands, but "in negative", showing that the pigments have been applied to the wall around the outline of the hand. It is thought that primitive man used his hand as a mask and blew colour through a hollow bone to create the picture of his own hand.

The history of the airbrush, in the form that we know it today, really begins in the late nineteenth century. In its early years, around the turn of the century, the airbrush was generally used for sign painting and for producing stylized lettering, but already artists were beginning to use airbrushing to portray the human form, often in a realistic style. Some artists had realized that the airbrush opened up new possibilities in the way that they could express themselves, and the development of true airbrush art was under way.

The real breakthrough came in the 1930s when *Esquire* magazine began publication, orginally as a fashion magazine for men. Its first issue contained a pin-up girl airbrushed by George Petty; and the "Petty Girl" soon acquired her own enthusiastic following, particularly among American servicemen who would cut out Petty's illustrations and "pin up" the girls in their rooms and in their tanks and aircraft.

Taking the place of the Petty Girl, the Varga girl first appeared in *Esquire* in 1940. The artist's name was actually Vargas, but the final letter was dropped by the magazine. Vargas' style was very distinctive, having less of a cartoon feel than Petty's work. The Varga Girls combined an erotic quality with a girl-next-door wholesomeness, a combina-. tion which made them more famous than the Petty Girls.

Vargas airbrushed several Varga Girl calendars, which sold in huge quantities. These calendars even featured in a legal battle between *Esquire* and the US Post Office. The Post Office charged a lower rate for mailing bona fide artistic

and literary publications, and Varga calendars took advantage of this concession. When the Post Office challenged *Esquire's* right to describe the Varga calendar as artistic or literary, a lengthy courtroom tussle ensued, but *Esquire* finally won the day.

In the 1950s, Vargas began to work for *Playboy* magazine. His work had by this time reached perfection, and early issues of *Playboy*, featuring Varga Girls, are now collectors' items. In later years the fashion for airbrushed pin-up girls diminished, because there was a growing acceptance of magazine photographs showing girls in the revealing costumes and poses that had characterized Vargas' airbrushed artworks.

Artists always keep a keen eye on each others' techniques, and so the work of Petty and Vargas brought the capabilities of the airbrush to the attention of a new generation of artists and illustrators. The unique possibilities offered by the airbrush made it ideal for the clean, modern style favoured by advertising art directors. Also, many hobbyists took up the airbrush for their own satisfaction rather than for commercial purposes.

When it comes to airbrushing the human form, there are an infinite number of possible styles, ranging from strict photo-realism to total fantasy. The airbrush can create a face with delicate skin tones and moist eyes, but it can equally create a science-fiction alien or a surreal study in which texture, form and colour can be manipulated to suit the artist's imagination.

The examples given in the following pages cover not only basic draughtsmanship and the skills required for airbrushing the human form, but also show how the reader can develop his or her own individual style — whether it be for pleasure or merely for profit. Although there is already a long list of famous airbrush artists and their work would fill several shelves full of books, airbrushing is still developing and the best airbrushed artworks of the human form have probably not yet been created. This book should contribute to their realization!

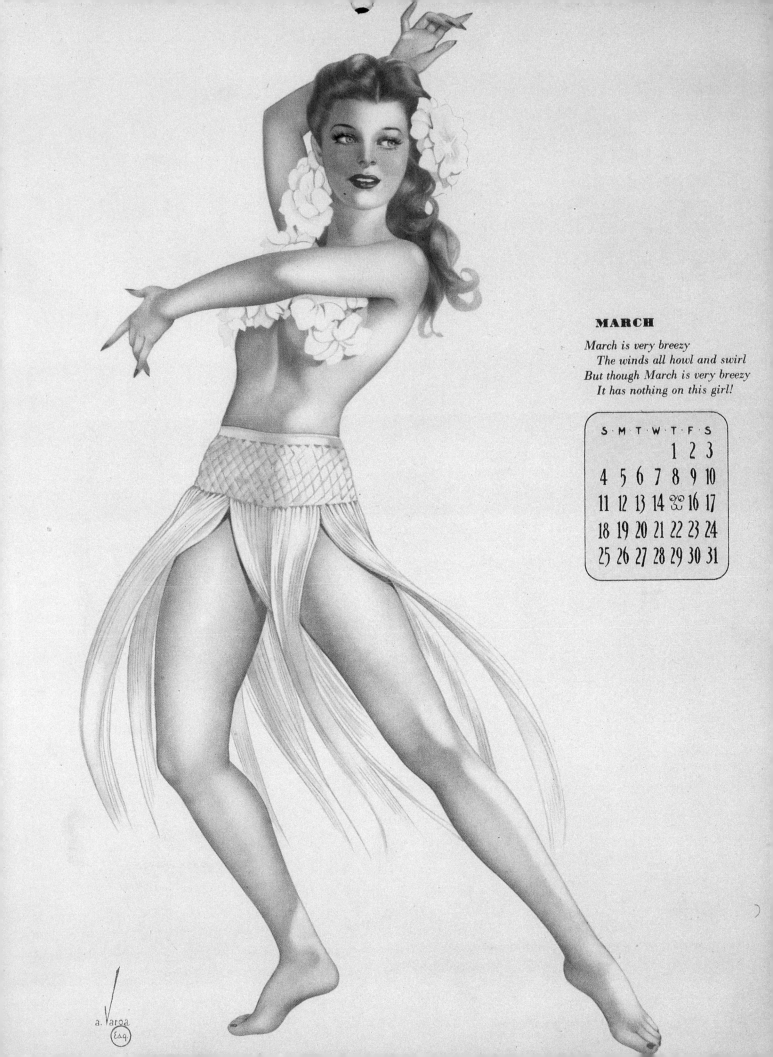

MARCH

March is very breezy
 The winds all howl and swirl
But though March is very breezy
 It has nothing on this girl!

S	M	T	W	T	F	S
				1	2	3
4	5	6	7	8	9	10
11	12	13	14	15	16	17
18	19	20	21	22	23	24
25	26	27	28	29	30	31

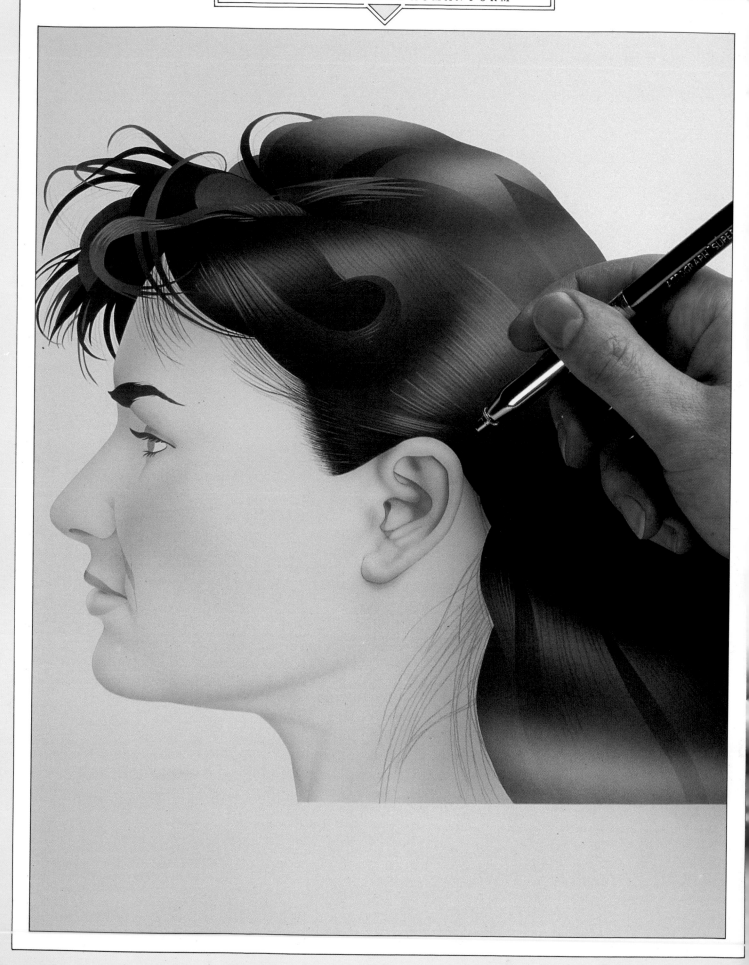

MATERIALS AND EQUIPMENT

AIRBRUSHES

COMPRESSORS

GENERAL EQUIPMENT

MEDIA

SUPPORTS

MASKING

WORKING ENVIRONMENT

AIRBRUSHES

The first airbrush was invented in 1893 by Charles Burdick and the basic design has changed little since that time. The ability of the airbrush to produce subtly graded colour and smooth tones soon made it a favourite with artists who wished to portray the human form. Indeed, Vargas, whose pin-up girls were immensely popular in the 1940s, probably did more than any other artist to bring the airbrush to prominence.

There are three main types of airbrush, which are readily available from many manufacturers. The simplest and cheapest design is the single-action airbrush, which lets you control only the flow of air — in effect, it has an on/off switch. In order to vary the density of paint, you would have to vary the distance between the airbrush and the support. On the whole, this type of airbrush, although temptingly cheap, is probably not a good buy if you want to produce fine work on a relatively small scale.

Slightly more sophisticated is the double-action airbrush. The flow of medium and air is again controlled by a single lever, but the first part of the lever's travel starts the air flowing and the next stage lets the medium into the air stream. This means that you can begin each pass of the airbrush gradually, and finish spraying the medium before moving the airbrush away. However, the ratio of medium to air cannot be varied while the airbrush is in use, though some models allow you to pre-set a specific ratio before you begin to spray.

The independent double-action design of airbrush gives far greater control and is the type favoured by professionals. In this design, the lever is pressed down to allow air to flow, and pulled back to regulate the amount of medium drawn into the air stream. A skilled airbrush artist can thus produce any density of paint from a fine spray to an opaque wash.

There are two other airbrushes which work on different principles. One is very simple and uses large felt-tipped marker pens for the source of its medium. The air stream draws the medium from the marker pen and sprays it onto the support. This kind of airbrush is cheap and cheerful, allowing low-cost airbrushing, particularly if you use canisters of propellant. On the other hand, delicate work cannot really be achieved using this design.

At the other end of the scale is the Paasche Turbo. This airbrush is far more complicated — a needle moves in and out of the reservoir of colour and the airstream blows the colour onto the support. The Paasche Turbo is capable of producing extremely fine lines but is generally not used as an all-round airbrush. Many professionals have a Turbo in reserve and use it only when fine work is needed.

There are other design features of airbrushes which may cause you to choose one type rather than another. Siphon-feed airbrushes have large colour cups, or colour jars, mounted underneath or on the side of their bodies, whilst gravity-feed airbrushes have a smaller colour cup permanently fixed on top of the airbrush.

The best advice is to buy the airbrush that you feel is the most comfortable to use.

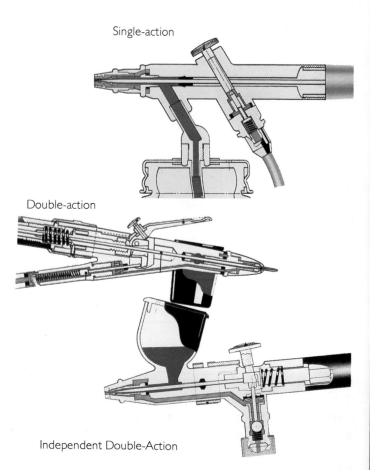

Single-action

Double-action

Independent Double-Action

Although it has cheapness on its side, the single-action airbrush is an extremely basic tool and not suitable for fine work. The double-action airbrush is more sophisticated and allows for greater control; but for smooth skin tones and the delicate details of the human form, the independent double-action airbrush would be the preferred choice.

COMPRESSORS

The source of the compressed air needed to drive your airbrush is a very important consideration. As compressors can be expensive, it is worth deciding from the outset what sort of use you will be making of your airbrush — this will, on the whole, dictate the type of compressor you need.

If it is likely that you will use your airbrush on rare occasions only, and particularly if you are short of storage space in the home, it is worth using an aerosol-type canister of propellant. For regular use, these "canned air" containers (which actually contain carbon dioxide or freon) become extremely expensive and if you intend to use an airbrush frequently it would be uneconomical to rely on them. However, they are useful if you need to work away from home.

Larger cylinders of carbon dioxide are available from specialist suppliers and work out cheaper than smaller aerosols in the long run. Like canisters of propellant the pressure drops as the container empties, but a pressure regulator fixed between the air supply and the airbrush will minimize this effect. Many pressure regulators are combined with a moisture trap which collects water vapour from the compressed air so that it does not condense inside the air hose and airbrush itself. Water condensation can spoil your artwork by affecting the dilution of the colour.

More regular users of the airbrush will probably want to invest in a compressor. The simplest and cheapest type is the diaphragm compressor. This design produces a continuous supply of air but it does so in pulses. This pulsing effect can cause difficulties when you are doing particularly fine and delicate work, such as creating a flawless complexion.

Somewhat more expensive is the storage compressor. This design includes a storage vessel into which compressed air is pumped and from which it is delivered to the airbrush — this eliminates the pulsing effect. A more sophisticated type of compressor uses a piston to compress the air, which is then stored under pressure until it is needed.

The most expensive compressors are fully automatic. The motor runs until a pre-set pressure has been built up in the storage tank and then the motor cuts out until the pressure drops to its lower limit. This class of compressor can be run for long periods without overheating and is available in many different sizes. Larger models have enough capacity to run several airbrushes at once. Compressors like this are generally found only in the commercial studio, but a smaller

automatic compressor will undoubtedly help you to achieve a good standard of work.

Housing a compressor can be a problem — cheaper models can be noisy and any compressor can get kicked if it is not tucked out of the way. A noisy compressor can be partly silenced by housing it in an insulated box — if you do this, make sure that there are plenty of holes in the box so that the compressor can take in air and give off heat.

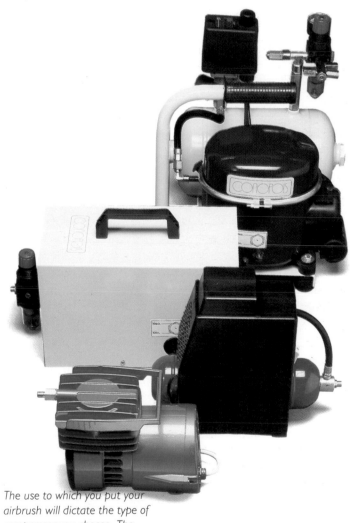

The use to which you put your airbrush will dictate the type of compressor you choose. The choice is wide: from models that power only one airbrush to those which have built-in storage tanks and can power a number of airbrushes at once. Even the simplest model is fairly expensive, so consider your options with care.

GENERAL EQUIPMENT

Apart from specialized airbrushing equipment, there are many straightforward items that you should obtain when you are setting up your studio.

GENERAL EQUIPMENT

Sharp pencils of varying degrees of hardness are essential, as well as sketch pads and pads of tracing paper. Coloured pencils and felt-tipped pens are also extremely useful for preparing roughs. A good technical drawing pen with a selection of different-sized heads will be invaluable. The heads contain tubes which produce lines of constant width when they are held at a right-angle to the support.

You will require sharp scissors and a scalpel for cutting masks, and a supply of scalpel blades so that you always have a sharp blade to hand. An ordinary eraser and an eraser pencil are useful for removing unwanted lines and for rubbing back an artwork.

It is helpful to have several different sizes of sable brush both for use on the artwork and for mixing colour and transferring it to the colour cup of the airbrush. Although some artist's media are supplied with small mixing cups, an artist's palette is still very useful for mixing colours on — plastic palettes are available but many artists prefer the more traditional ceramic types with mixing wells to hold the thin media that airbrushes require. These palettes have the additional advantage of being easy to clean.

DRAWING INSTRUMENTS

Even though parts of your picture may be created freehand, specialist drawing equipment will help you to produce your best work. A set of drawing instruments will be useful, even for a non-technical artist. In particular, a pair of dividers can hardly be bettered for checking that you have a dimension correct and for reproducing the same dimension in several places.

A set of compasses is also useful, to draw arcs and circles in a wide range of sizes. A selection of rulers often come in handy too. If you want to use a ruler as a straight edge for cutting, a metal ruler is better because it will not be damaged by the edge of the blade, whereas plastic or wooden rulers soon become ragged when used for this purpose.

CURVES

Drawing accurate curves is one of the tricks of the trade. This is especially true when you are portraying the human form which consists entirely of curves. There are various items of equipment which will be helpful here. One of the most useful is a set of French curves. These are plastic templates of varying sizes, each one containing curves of different radii. They can either be held against the artwork itself and used as a mask, or used as a guide when cutting masks. In either case, a whole curve or any part of a curve can be reproduced.

To produce a larger or more complex curve, a flexible curve is ideal. This is a strip of flexible material which will hold the shape into which it has been formed.

If you are using a three-dimensional reference, such as a model, a form guide or profile guide will help you. These guides consist of rows of fine teeth set close together in a holder which is held at a right-angle to the shape and then gently pressed against it to make the teeth move back, leaving an accurate representation of the shape. You can then draw around the form guide on a piece of paper to make a mask — the guide itself is not suitable as a mask because the teeth will give a jagged edge.

AIRBRUSH EQUIPMENT

Some other items of general equipment which will make your life easier include an airbrush holder, which will keep your airbrush horizontal if you need to put it down while there is still colour in the cup.

If you do not have the advantage of running water in your studio, a supply of distilled water should be kept for use when mixing colours and flushing out the airbrush. If you do use tap water and live in a hard water area, you should add some water softener to it because hard water deposits can ruin an airbrush in a relatively short time.

A supply of solvents will be required for cleaning out your airbrush. If water will not flush out all the colour, methylated spirits should do the trick. As a last resort, hydraulic brake fluid will dissolve most of the stubborn media. Make sure that these highly flammable and dangerous substances are kept well away from direct heat, animals and children.

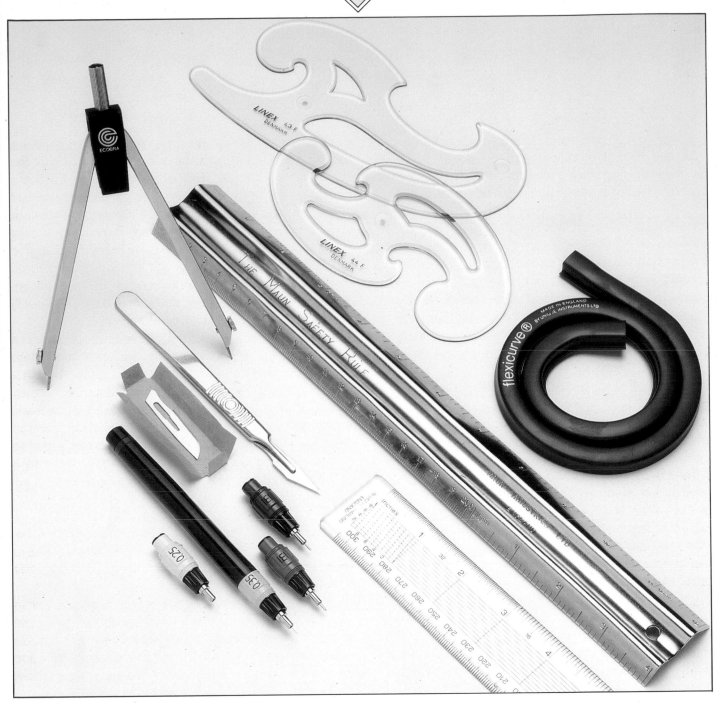

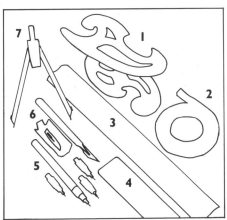

1 A set of French curves is a necessity when portraying the human form, consisting as it does entirely of curves. **2** For more irregular shapes the flexible curve is ideal. It is easily moulded into the required form, which it will retain until re-moulded. **3 & 4** Rulers are essential pieces of equipment. Remember to always use a metal rule with a scalpel! **5** Technical pens are invaluable when lines of a constant width need to be reproduced. **6** The intricate mask cutting required to depict the human figure would never be possible without a scalpel. **7** Dividers provide a very quick and easy way of transferring an image from one surface to another.

MEDIA

Any substance sprayed or brushed onto a support is termed a medium, but not all media are suitable for use in an airbrush. Some can be made suitable by the addition of appropriate diluents and retardants, which stop them from drying so quickly that they clog up the airbrush. Others cannot be used in an airbrush at all, either because they contain particles which are too large to pass through the fine passages inside the airbrush, or because they contain corrosive substances which would attack the inside of the airbrush and drastically reduce its working life. Manufacturers of media often state on the packaging whether or not a particular product is suitable for airbrushing, and will be pleased to answer any queries you may have.

WATERCOLOURS

The most suitable media for airbrushing, and those that have been around for the longest time, are water-based. Indeed, the inventor of the airbrush was a watercolourist and designed the airbrush to help him in his craft.

Basic watercolours normally come in one of three forms — a solid cake of colour, a tube of semi-liquid colour, or a tub of thick paste. All these forms have to be diluted (preferably with distilled water) for airbrushing, to the correct consistency. Relatively recently though, some manufacturers have brought out watercolours especially made for airbrush use. These colours come ready-diluted and are often supplied in bottles with droppers which facilitate both the control of the colour mix and the loading of the colour cup.

Watercolours come in a wide range of colours, most of which resist fading. Some colours are termed fugitive, which means that they can fade away very quickly. Most reputable manufacturers will mark their paints and grade them according to how permanent they are.

Colours will also be marked with their relative staining qualities — this is important information because a colour that stains heavily may bleed through subsequent layers of colour sprayed on top. The opacity of a colour will also be indicated. Watercolours themselves are transparent, so you should be careful to choose an appropriately coloured support. The delicacy and transparency of watercolours make them ideal for depicting flesh tones and eyes.

Gouache is watercolour to which precipitated chalk has been added, to increase its opacity. You can, for instance, use a light-coloured gouache to cover up a darker colour, whereas this would be impossible with watercolour. You must remember, though, that a base colour with a high staining ability must be completely dry before you apply another colour over it, otherwise severe discoloration may result. Like watercolour, gouache comes in a wide variety of colours, but they usually vary in opacity — again, this should be indicated on the packaging.

INKS

Most inks, both waterproof and non-waterproof, are suitable for use in an airbrush. However, if you let the waterproof kind dry in your airbrush it will be difficult to clean it out. A mixture of the two types of ink will also tend to clog up the airbrush if it is not flushed out directly after use.

Inks are not available in as wide a colour range as watercolours, but the colours that are made are brilliant and have a sheen which makes them very suitable for depicting face make-up such as lipstick, and silky clothing.

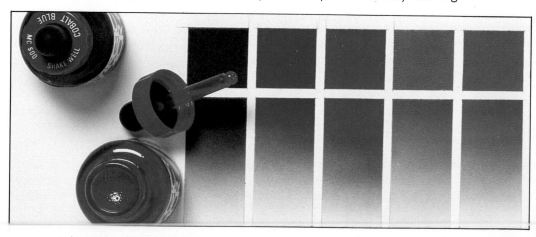

Inks suitable for airbrushing are available in both waterproof and non-waterproof varieties. Bear in mind that waterproof ink that has been allowed to dry in the airbrush is very difficult to clean out.

ACRYLICS

Acrylic paints, which are made from a synthetic material similar to that used for dentures, are available in a large range of rich colours. Some acrylics can be diluted with water, whereas others need special thinners. Most acrylics have a tendency to dry in the airbrush, and if you do let this happen accidentally, special solvents will be required to clean the airbrush. However, some manufacturers have brought out new acrylics specially made for airbrushing. These have a longer drying time which reduces the likelihood of the airbrush becoming clogged. When dry, acrylics are very hard wearing.

OILS

Oil paints are made in the largest colour range of all the various media but they are not very suitable for airbrush use. They are extremely thick and need to be thinned with turpentine, which is a time-consuming and tricky process. Even when thinned down for airbrush use, oil paints take a long time to dry. You can use additives to hasten the drying process, but these tend to change the colours slightly.

Oil paints can stain untreated supports and some oils are not compatible with other media — if you are planning a mixed-media artwork including oil colours, it is best to check with the media manufacturers that this is possible.

LACQUERS AND METALLIC PAINTS

Some lacquers and metallic paints are suitable for use in an airbrush and will probably be labelled accordingly, but many metallic paints are merely paint with metallic flakes stirred into it, and these can easily clog up an airbrush. When using lacquers or metallics, the airbrush should be flushed through regularly.

Remember that many oil paints, as well as cellulose-based and acrylic media, are flammable, so they should be kept well away from naked lights and cigarettes. You should ideally wear a face mask when spraying these media as they can be harmful if inhaled.

COLOURS

Colour is a property of light. When white light (which contains all the colours) strikes a colouring agent, some of the colours are absorbed by that agent and the other colours — the ones that we see — are reflected back to the eye. The perception of colour is a very personal thing. It is impossible to say whether any other person sees exactly the same colours as you do.

In pigments, there are three primary colours — red, blue and yellow. Mixing two primary colours together will give you a secondary colour, for instance mixing blue and yellow gives green. Mixing a primary colour with a secondary colour gives an intermediate colour, for example the result of mixing yellow and green is a colour between the two — yellow-green.

Even when you are using a medium which is available in a wide range of colours you will sometimes wish to mix your own colours. Some media which are made in a relatively restricted range of colours are accompanied by mixing charts which give detailed instructions on how to reproduce hundreds of colours accurately. The basic point to remember when making up your own colours is that the mixed colour will be less bright than its brightest constituent. The intensity of a colour is reduced by adding that colour's complementary colour — in other words, its opposite. A colour wheel with the three primary colours spaced evenly around the edge and the intermediate colours in between will enable you to see which is the complement of any given colour.

In many ways, working with colours can be difficult. Trying to match an existing colour can be tricky, especially if you do not know how many layers of colour were applied to achieve the result. Most media appear to be darker when they are wet; so before applying a colour, spray a little on a practice support and let it dry to see its true shade. The other colours in a picture can also affect the appearance of the individual colours that have been used. As with all aspects of airbrushing, practice is the only route to success.

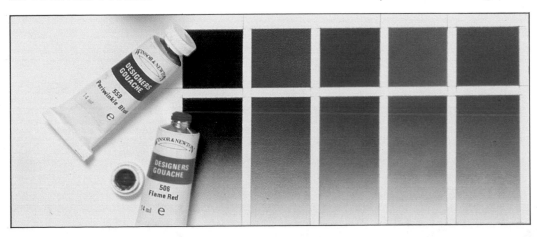

Gouache, being water-soluble, is a highly suitable medium for airbrushing. However, because it is far more opaque than watercolour, it is not always appropriate for creating delicate skin tones.

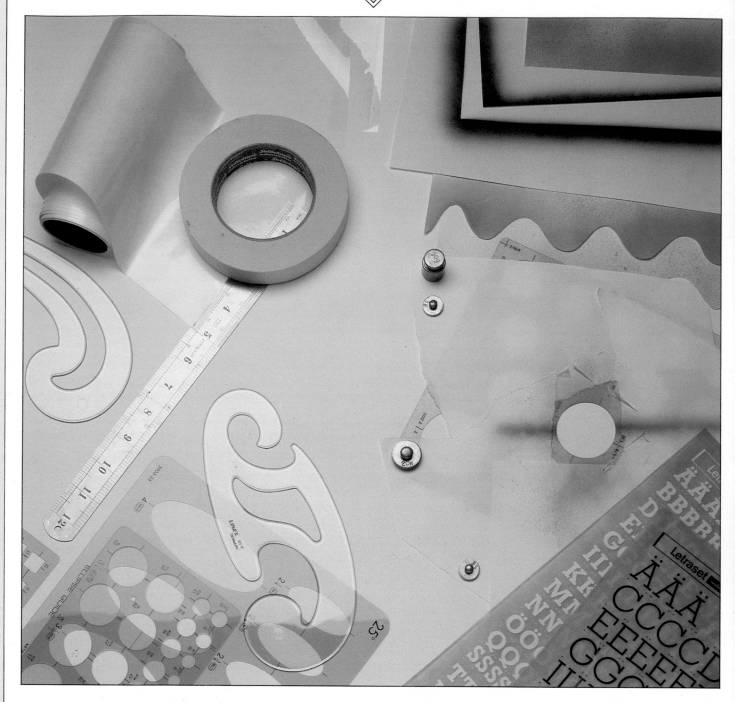

Practically any material that prevents media from seeping through can be used as a mask. **1 & 2** Card is ideal for masking when a hard edge is required. **3** Plastic templates are available in countless shapes, but don't forget to mask out the ones you don't want! **4** French curves provide virtually every degree of curve required. **5** A ruler is handy for creating an instant straight edge. **6 & 7** Masking film and acetate are custom-made for the job:

they can be cut to any shape and have the added advantage of being transparent. **8** Masking tape is low-tack and ideal for securing any type of mask to a surface.

MASKING

An airbrush can be used freehand, but it is generally true to say that the accurate and creative use of masks is the key to successful airbrushing. Almost anything that completely or partially prevents paint from passing through it can be used as a mask.

FIXED MASKS

Masks can be divided into two broad categories — fixed and loose. Airbrushing, by its nature, tends to produce a soft edge, so if you are depicting a sharply defined line, between a person's profile and a light-coloured background, for example, a freehand spray will not create the right result. To produce a hard edge, fixed masking is normally needed. The traditional method is to use frisket — a transparent, water-resistant paper which is stuck to the support by rubber cement. The frisket is then cut out as required with a scalpel, and peeled off carefully. Any rubber cement that remains is rubbed off, taking with it any dust or grease on the surface. You then spray up to and onto the edge of the frisket, and when dry, peel the mask off the paper. Frisket is also very stable. If you need to replace a mask, it will not have stretched or shrunk.

Another alternative is masking film. This film is self-adhesive and comes with a backing paper which should be removed only when the film is about to be used, because dust particles soon settle on the adhesive side and reduce its effectiveness. The film adheres well to the surface of the support, and as it is "low tack" can be removed from the surface with little or no risk of lifting fibres from the support.

Masking film and frisket are available in several widths, as are tracing and greaseproof papers — household items which could be used in an emergency and stuck down with rubber cement. However, you might need to iron them first, to ensure that they are perfectly flat.

If you are masking off a large area, using masking film or frisket will be expensive; it is just as effective to use film or frisket to mask just the area you are working on, and mask the rest of the board with ordinary paper which overlaps the film or frisket and is secured to it with masking tape.

Liquid masking can be applied with a brush and is very useful for small areas, but it dries very quickly and may do so on the brush, making it difficult to use for large-scale masking. It is also unsuitable for use on anything but a blank support because it needs rubbing to remove it and this action may spoil any colour you have already sprayed. If you intend to use liquid masking, be sure to test it with your chosen support and medium because some liquid masks can cause stains which show through some colours.

LOOSE MASKS

Loose masks can be almost anything you choose, and give the most scope for individual creativity. Cotton wool, for instance, can be pulled out and shaped to create the outline of a head, giving a naturalistic, soft edge to the hairline. Acetate, which has no tack, is easily cut to shape and has the advantage that the underlying picture is easily seen through the mask. Any medium sprayed onto the acetate mask can be wiped off, if not left too long, so that the mask can be used again. The acetate mask can either be used as a loose mask or held down with masking tape or rubber cement.

If you are producing a life-sized head and shoulders portrait you can, if you are careful, use actual objects such as brooches and hair ornaments as masks for their own shapes. Even though some masks have sharp edges, if they are held slightly above the surface of the support they will produce a softer outline. To hold a mask level but slightly above the surface, place it on coins or attach it to the support with small pieces of Blu-Tack.

There are a large number of ready-made templates which can be used as loose masks. Some of the proprietary curves are just right for curves such as a jawline or the shape of the shoulders.

If you create a particularly successful shape for a difficult area such as a hand or an eye, it is useful to make a permanent record of it by cutting out the shape in a sheet of acetate and storing it for future reference. This technique will help you to build up a library of successful masks.

SUPPORTS

Any surface that will accept a medium is termed a support, or ground. In theory, any support could be used for an airbrushed artwork.

PAPER

The cheapest and most readily available support is paper, and the best paper for airbrushing is machine-made and acid-free. The best-quality acid-free mounts and supports are described as "conservation" or "museum" quality — these grades should be used for all your finished artworks.

Most manufacturers will specify which of their papers are suitable for different techniques, but even so, not all papers give satisfactory results with airbrushes. As a general rule,

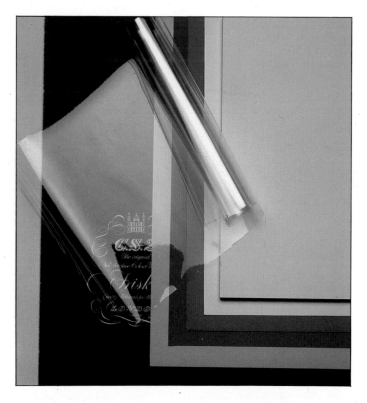

the lighter the weight of the paper, the less suitable it is for airbrushing. Virtually all papers tend to buckle if they become wet — for example, when a heavy wash of watercolour or gouache is applied. If your work involves washing a large area of the paper with colour, it is best to dampen and stretch the paper before use.

BOARDS

Boards will accept virtually any medium without distortion and are available in a range of colours. White is the most versatile colour, particularly if you are using a transparent medium such as ink.

Acid-free Bristol board is probably the most commonly used and versatile support. Bristol board is a laminate made from a number of sheets of paper. The board number tells you how many layers there are and therefore how thick it is.

Ordinary artist's board is made from a thick layer of pulp with a sheet of fine-quality paper attached to its surface.

A recently introduced conservation-grade support consists of a flexible sheet of polystyrene sandwiched between two sheets of acid-free paper. If your artwork does not turn out quite as you had hoped, it is always possible to turn this kind of two-sided board over and try again.

When using a support for the first time, it always pays to do some practice masking and spraying to familiarize yourself with its handling characteristics.

For example, the more textured boards, which almost give the look of an "oil painting" to your portraits, are difficult to mask because of the irregularity of their surface; and a drawback of cheaper, lower-quality boards is that their surface fibres tend to lift off when you remove the masking.

ACETATE SHEETS

Transparent acetate is another popular support and can be bought in a range of colours as well as in a clear form. Acetate is particularly useful for making overlays — for instance, if you wanted to airbrush a fashion model onto board and then create a variety of outfits on separate acetate sheets.

The surface of acetate tends to repel fluids, so you need to add a little gum arabic or a proprietary equivalent to the medium in order to help it to adhere — you should not try to put a key on the surface of the acetate or you will impair its transparency and remove some of the built-in colour.

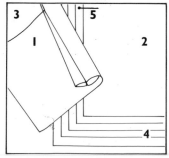

I *Acetate is generally used for masking, but is also appropriate as a support.* **2** *Cartridge paper is cheap, but can cause problems of bleed.* **3 & 5** *Ivory and CS2 board provide the perfect support for most media without distortion.* **4** *Watercolour paper speaks for itself and is available in a wide range of colours.*

ENVIRONMENT

The airbrush artist needs space to work in — as a rough guide, four square metres is the least you should give yourself. Although it may be difficult to obtain, if you are intending to practice airbrushing on a regular basis, a special room or even a well-constructed shed or garage should be set aside as your studio.

VENTILATION

Though relatively unimportant in an ordinary artist's studio, ventilation is a top priority in an airbrushing studio. Several of the colours, such as all those that contain cadmium, include toxic substances, and some thinners and cellulose paints contain volatile substances which can cause intoxication. A window that opens is not enough — on cold days, many people will be reluctant to open it, and also an open window can let in dust which may contaminate your work. An extractor fan is the ideal solution — if it is not possible to install one, an electric cooker hood with renewable filters will serve the purpose. If your studio has air conditioning, a special filter should be fitted to the unit to prevent noxious paint fumes from circulating round the building. Many artists also wear face masks to avoid inhaling paint spray.

TEMPERATURE

The temperature in the studio should be kept as low as is comfortable. The warmer the air is, the more water vapour it can hold, and saturated humid air can have a very adverse effect on your artwork.

LIGHTING

Lighting is also of great importance. A north light is traditionally favoured by artists, but artificial lighting is a necessity if you want to work late into the evening. Many people prefer daylight fluorescent tubes for general lighting and an adjustable worklight focused on the actual work area. A right-handed person should have the worklight shining from the left to avoid unwanted shadows.

As an alternative to fluorescent tubes, colour-corrected spotlights are acceptable.

WORKING SURFACES

The ideal working surface is an adjustable drawing board — a good-quality board can be adjusted for both height and angle. The surface of the board should be a light, neutral colour, as should the rest of the work surfaces, walls and ceiling in the studio. White paint should be avoided because it can produce glare — choose a colour that is restful to the eye.

SEATING

The artist's seating should be considered next. An adjustable chair on castors, such as a typist's chair, is ideal. If no such chair is available, choose a comfortable chair of the right height to allow you to work easily at your board.

STORAGE

Storage often presents a problem in the studio. Open shelves, just deep enough to store items such as tubes of paint side by side, are ideal for many of the artist's sundries, but a dark cupboard is needed for the storage of supports. Exposure to light will cause many supports to darken and change colour; sunlight can also cause some types of acetate sheeting to become brittle.

The other consideration is storage of the finished artwork, which has to be stored flat; so you will need wide, shallow drawers. A plan chest is obviously ideal, but an old-style linen chest with sliding trays, or a yachtsman's chart chest would do the job. If necessary, treat the inside of the chest to make sure that the environment is acid-free.

If you are temporarily keeping artwork in a portfolio, make sure that the portfolio itself is made from conservation-grade materials. Avoid plastic portfolios and those made from unknown materials as these can have serious effects on your work. Wherever you store your finished work, surround it with acid-free tissue paper and place layers of this tissue between each separate artwork.

You need to keep your working environment clean and tidy. Dirt and dust can transfer to your work, and unless things are kept strictly in their place they will not be to hand when you want them. Also, unnecessary clutter around your work could easily mean accidental spills that can ruin hours or even days of work.

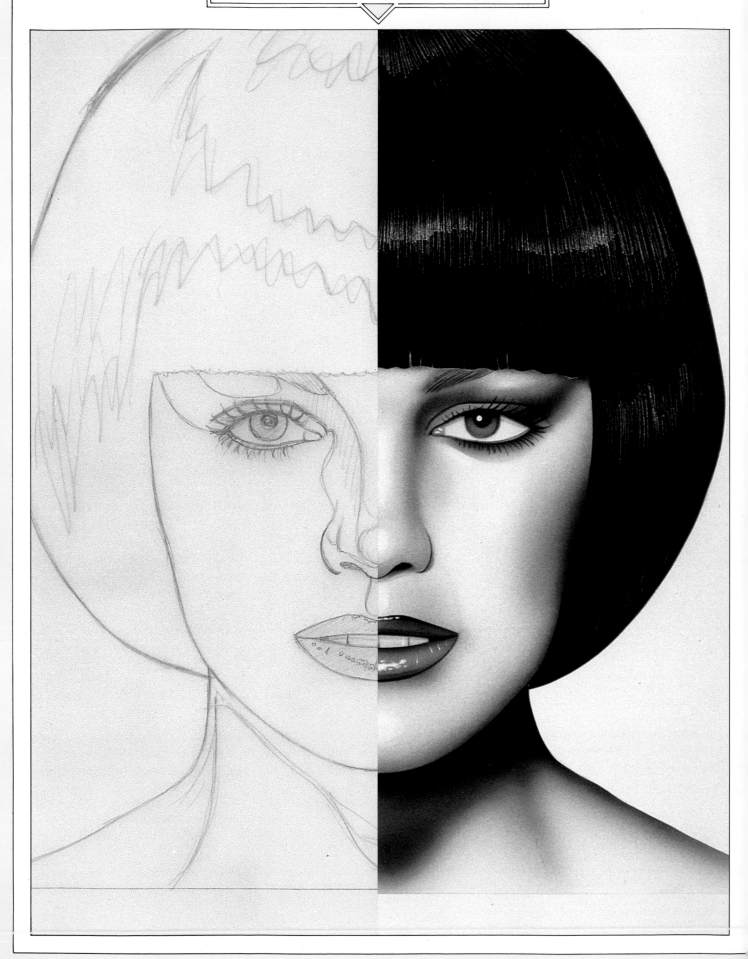

DRAWING FOR AIRBRUSHING

GETTING THE BASIC DRAWING
RIGHT

EXERCISES IN TEXTURE
AND TONE

REFERENCES

GETTING THE BASIC DRAWING RIGHT

The final airbrushed artwork of the human form can only be as realistic as the original drawing on which it is based. Most of the great artists throughout history have studied drawing so that they could portray their subjects realistically, even though they may later have developed their own distinctive and less realistic style. It is very easy to practise drawing because the only items of equipment needed are pencil, paper and an observant eye.

GETTING A FIGURE INTO PROPORTION

Any representation of the human form will look unrealistic if the basic proportions of the drawing are wrong. The simplest way to get the proportions right is to rule eight, horizontal, equally spaced lines on your drawing pad, then use the head of the model as the standard unit of measurement.

The most straightforward pose is the standing position. If it is not possible for someone to pose for you, you can always stand in front of a full-length mirror and draw yourself.

Hold a pencil vertically with your arm stretched out completely straight, line up the top of the pencil with the top of the model's head and then slide your thumb down the pencil until the thumb lines up with the chin. The distance between the thumb and the top of the pencil is one unit. It may be useful to mark the thumb point on the pencil.

You can vary the size of the unit according to the scale of your artwork, but the standing human form is usually seven or seven-and-a-half heads tall. If you wish to highlight a feature, such as long legs for a fashion pose, you can add about half a head to the overall length.

When you have sketched in the basic shape of the head between the top two lines, hold the pencil out again and line up the top with the model's chin. Holding your thumb on the one-unit mark, note whereabouts on the model's body the thumb falls, then sketch in the shoulders and upper body between the second and third lines. Continue in this way until you reach the model's feet.

The standing pose is the simplest to draw because all the limbs can be seen fully extended. When the model changes to a sitting position, the legs appear to be foreshortened but many artists still draw the legs as if their full extended length were visible, completely destroying the correct proportions of the seated figure.

Again, the pencil held at the end of the outstretched arm can be used to measure the correct proportions. This method will clearly show the apparent size of the foreshortened limbs in relation to other parts of the body. When you become more proficient at drawing, you will tend less to draw every part of the body as if it were fully extended.

Another useful technique for achieving correct proportions is the dropped line. If you can see, using your vertical pencil as a plumb line, that the model's knee is directly below his or her shoulder, a faint vertical line marked on your drawing pad will ensure that this relationship of shoulder and knee is preserved in your drawing. These lines can also be drawn horizontally or at any other angle to indicate two or more points that lie along the same line. Faint pencil lines are easy to erase at a later stage.

VOLUME

Once you are proficient at drawing a correctly-proportioned outline of the human form, the next stage is to create the impression of depth, so that the drawing will look three-dimensional. In other fields of art, perspective can be used to give depth to buildings, and relative scale makes the nearer and farther parts of a landscape combine to suggest the impression of depth. However, with the human form, these devices cannot usually be employed.

The main way in which volume can be suggested in a drawing of a human figure is by emphasizing the lighter and darker parts of the figure. The eye interprets this information as showing which parts of the figure are nearest to the source of the light, and which ones are farther away. If a face is lit from the side, the gradual deepening of the shadow on the side of the nose farthest from the light will show that the nose itself stands out from the face and is gently curved.

The intensity of the light striking the figure affects the contrast between the bright areas and those in shadow. A powerful light source directed towards the side of the model will produce the most marked shadows, and will help you to draw a three-dimensional figure more than would a softly lit model, which has a delicate gradation of shadows.

When you come to airbrush the drawing, the illusion of roundness and volume will be created by the shades and intensity of the colours on the board. If you have been used to spraying flat colours, you can rapidly develop the technique of building up volume by progressive applications of colour. Practise the technique first with pencil, crayon, chalk or

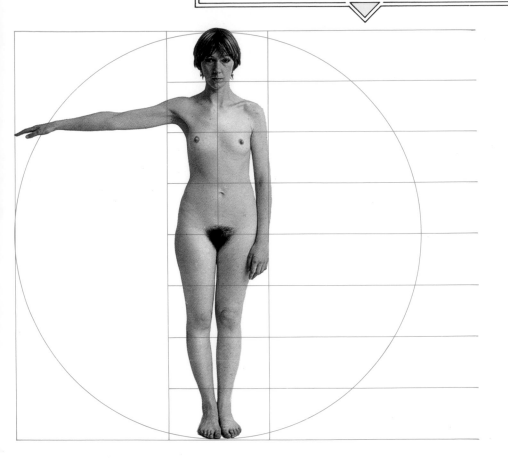

The head is a convenient unit of measurement. Most standing figures measure between seven heads, for a more compact person, and eight heads, for a taller, slimmer figure.

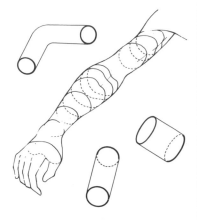

Although the human body is not really composed of geometrical shapes, it is useful to think about the three-dimensional forms that make up the body when planning the original drawing for an artwork. If the finished artwork is to look realistic and lifelike, every part of the body will need to appear three-dimensional, whether it is fundamentally conical, cylindrical or spherical in shape.

The viewpoint of the artist can influence the apparent proportions of the figure. As the angle of view changes, the ratio of the length of the legs to the total height of the figure also alters.

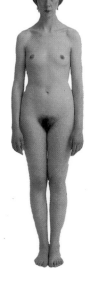

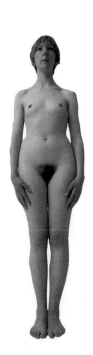

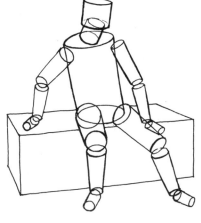

A basic sketch of a seated figure shows how the human form can be represented as a number of differently-sized cylinders. This preliminary drawing establishes the principal volumes of the body.

A regular shape, such as a cylinder or a tube, can be protrayed very simply, but the human body has a complex shape. The cross-section of the arm, for instance, varies constantly along its length.

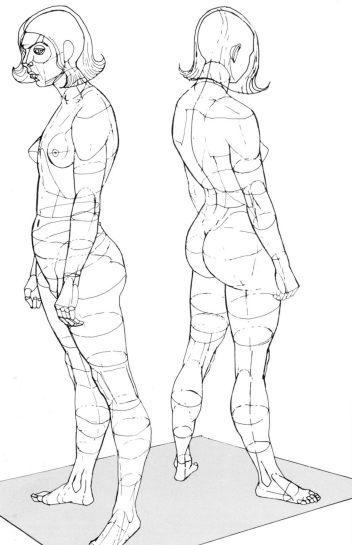

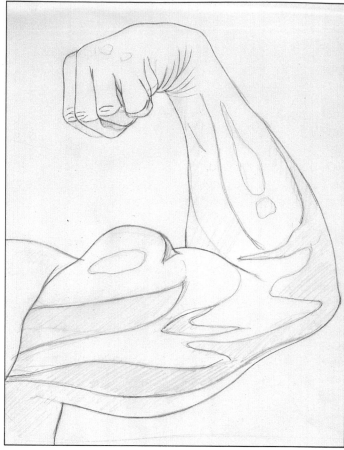

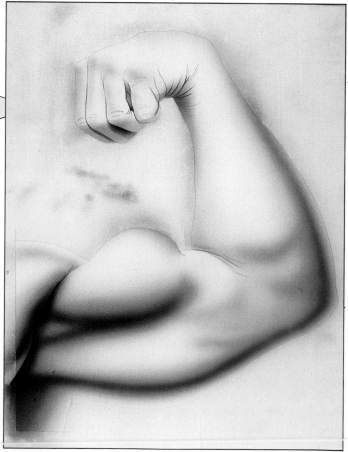

pastels. First, sketch the outline of the part of the body that you wish to portray, then add colour to it progressively, following the intensity of colour that the differences in light and shade have created on your model. You could hatch the areas that are lightly shaded, and then cross-hatch the areas on which darker shadows fall. Alternatively, you could experiment by varying the closeness of the hatching, so that in the darker areas the lines are closer together than in the lighter parts.

Gradually, you will be able to achieve the smooth progression from light to dark which is the hallmark of good airbrush work. Then, when you apply this technique to the

human form, you will already have a full appreciation of contours and how to give them a three-dimensional presence.

CONTOUR DRAWING

It cannot be stressed too strongly that the success of the finished artwork depends heavily on the quality of the original drawing. It is worth spending a lot of time getting the drawing right before beginning to airbrush. If you want the finished work to be very detailed, it is best to try to show all the detail on the drawing. The drawing should also show all the areas of shadow and light that will give life to the final image.

If you study any part of the body — for example, an arm — you will see that the highlights and shadows that give it its form are irregularly shaped. Therefore, when you sketch the arm, it is best not to show it as an assembly of regular shapes like cylinders and circles. Instead, try to reproduce the subtleties of colour and shadow as a kind of contour map on the sketch pad. Shade in the areas which will be the shadows and draw round the highlights. Even though this sketch will look artificial, because the real arm does not have contours marked on it, the different areas marked on your drawing will serve as invaluable guides when you come to airbrush the colours.

The way that a face is lit will affect the mood of the illustration and the degree of three-dimensional realism shown in the features. When the light shines onto the side of the face, the nose stands out prominently, but if the light shines straight onto the top of the head, the features can almost disappear.

The original drawing should show all the areas that will later be airbrushed in different colours or in variations of tone. Note that the areas of highlight are irregularly shaped.

When the airbrushing is finished, the "contour map" which was the original drawing acquires a three-dimensional look, with smoothly-graded tones giving an impression of volume.

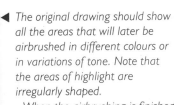

EXERCISES IN TEXTURE AND TONE

Age and sex are the great dividers, and the techniques required to portray an older man's head are naturally different to the ones you would employ for a younger, feminine head. In the following examples, shape and depth are given to the masculine head by emphasizing the lines and creases, largely through the addition of dark shadows; whereas the smooth, youthful skin of the girl is created by the artful use of highlights. In both cases, photographic references from different magazines were used for the original drawings.

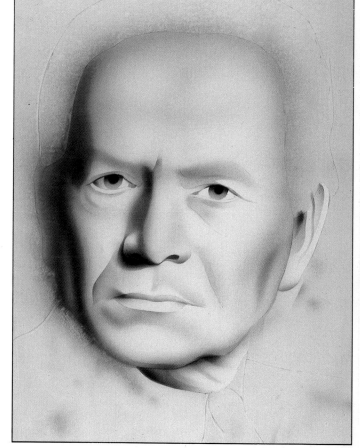

1 All the basic detail has been sketched in to show the main areas of shadow. The areas that will be white, such as the highlights in the eyes, were scratched out with an abrasive rubber. The range of tones in the hair is indicated by the different shaded areas.

2 Mix one part of quasar black with two parts of water. Mask the whole board, then cut the mask away to reveal the face and neck. Spray freehand, working towards the edge of the face, to build up the bone structure. For this portrait, separate masks were used for the eyes, nose, mouth and ears. The sharper lines were created by holding the masks nearer to the board.

3 Continue the basic shaping that gives the head its definition. Make the mix of the ink more concentrated than before, so that the black tones are bolder. The broader areas are still sprayed freehand, but smaller masks are necessary to define the line between the lips, as well as the wrinkles and eyelashes.

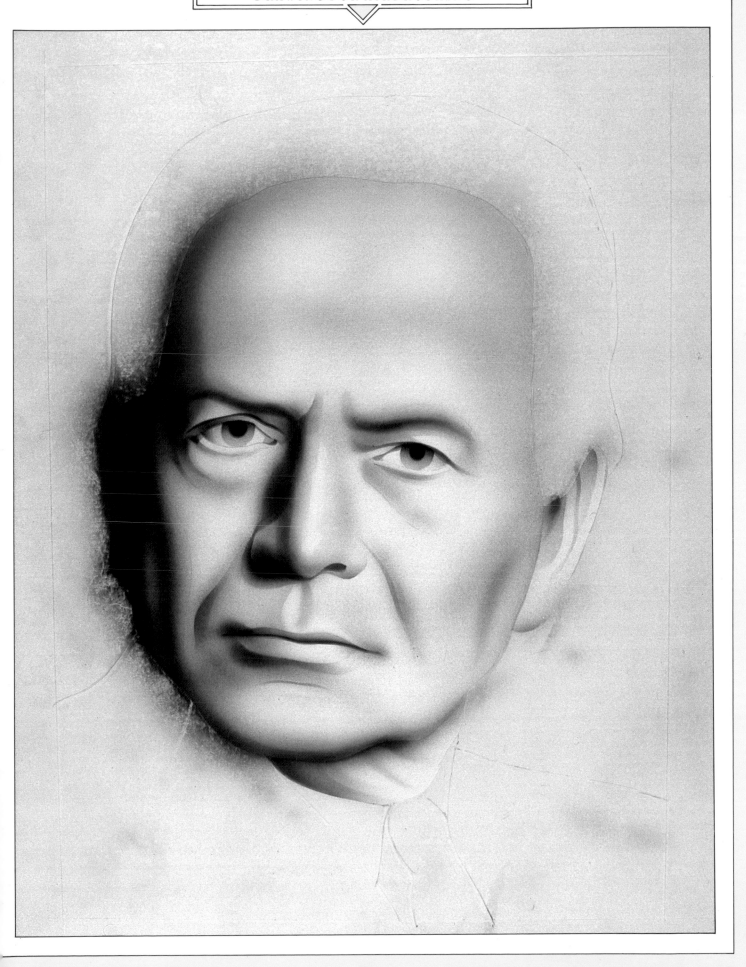

4 The strength of character in this man's face depends largely on the creases and lines of his face. Carry on working on the contours of the face, using finely cut masks for the creases around the nose and mouth. Again, the masks can be held slightly above the board to give a softer line.

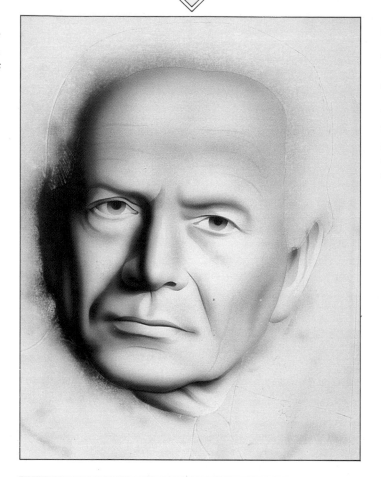

6 Remove all the masking from the board. Using a sable brush and quasar black diluted to give a light grey shade, add the detail around the hairline, the lines under the eyes and the additional touches in the eyebrows. Rather than painting them in with white, use a scalpel to scratch out the highlights in the eyes and in the hair.

5 Remask the face and neck with the piece of film that was cut away earlier. Reveal the hair and shoulders but leave the shirt and tie still masked. Spray a flat layer of grey over the jacket and hair. Give the jacket an extra spray of grey to darken its colour. Replace the mask for the jacket and reveal the shirt. Spray a freehand shadow under the neck and add the detail to the tie.

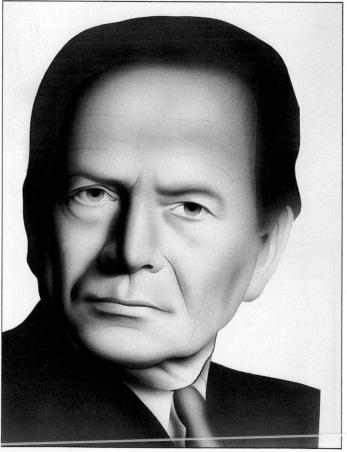

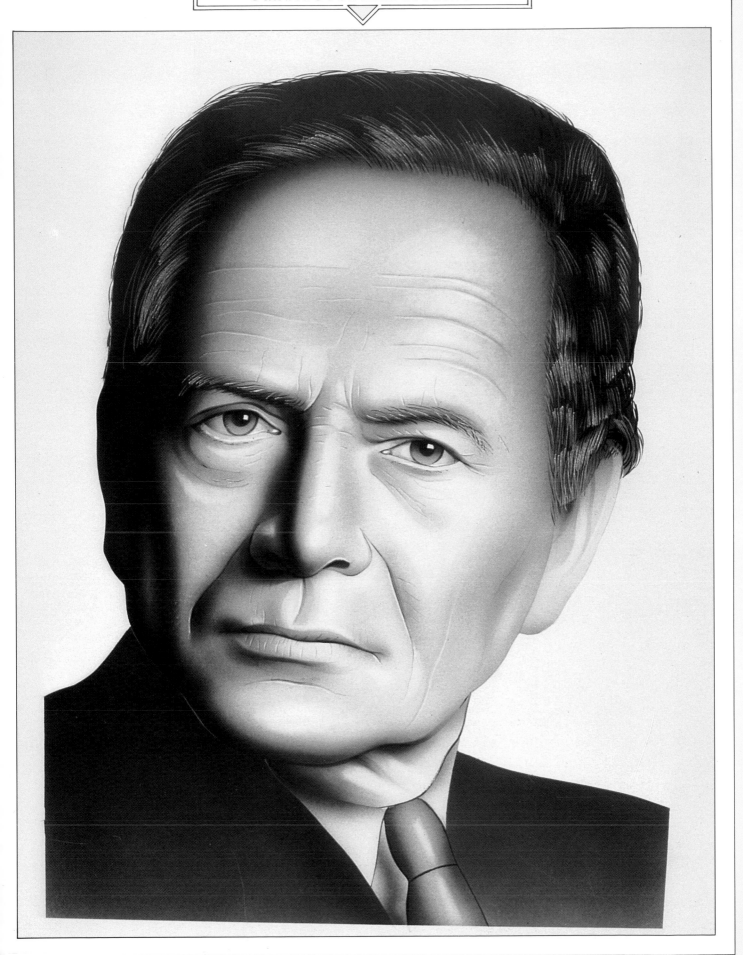

1 The initial drawing was carried out very carefully with all the highlights in the hair and around the nose sketched in. You could either draw the initial image freehand, trace it or use an epidiascope or Grant projector to transfer the drawing from the original reference to your own paper.

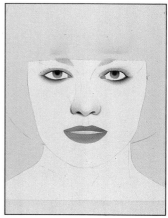

2 Cover the whole of your board with acetate, cut out the shape of the head and neck, and remove the cut-out shape. Dilute some black ink with water so that you get a grey tone. Cut masks for the eyes, nose and mouth and spray a light, even colour over these areas. Note that there is a separate mask for each lip.

3 The artist here made a positive mask for the chin and sprayed towards the mask to give a shadow under the chin; the neck and shoulders were coloured in the same way. The first spray of 'blusher' was applied freehand, then finished with a mask. For the eyes, a mask was cut for the edge of the eyelid. A loose acetate mask held away from the board gives the soft shadows around the nose.

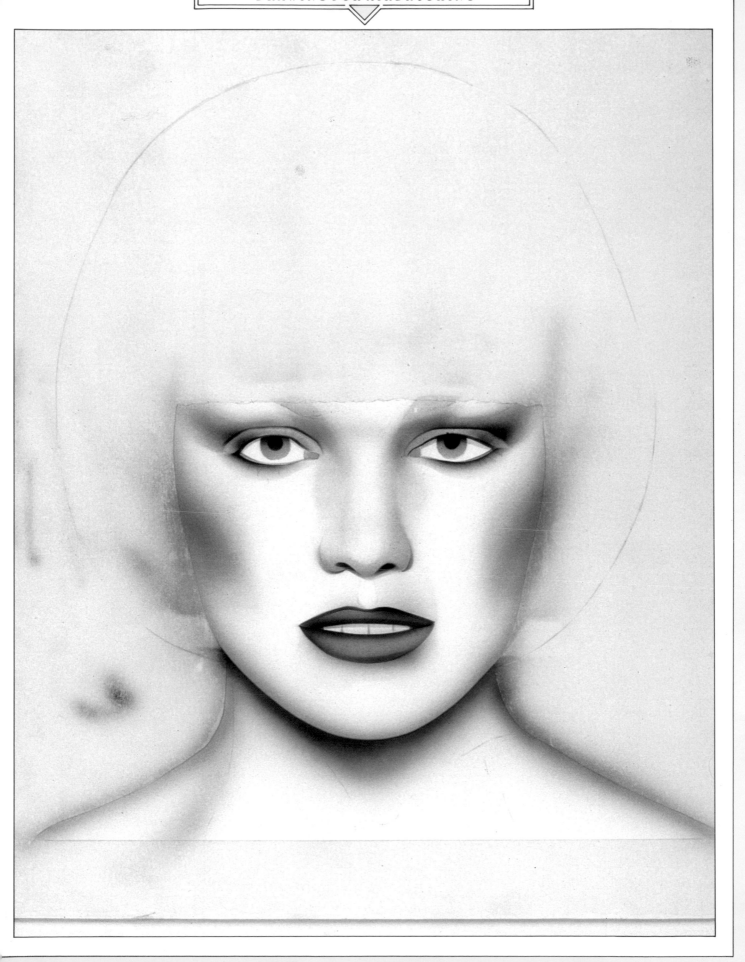

4 To add the details around the neck, cut out an acetate mask. Hold it down to the chin line but let it curl up over the neck. Spraying towards the chin gives a hard line which tapers towards the bottom. Mask the eye make-up to give a darker line inside the lighter area. Use a paint brush for the eyelashes, eyebrows, the lines around the lips and around the iris.

6 To add the finishing touches, scratch in the highlights on the lips and in the eyes. Another way of creating highlights is by using an eraser pencil to rub away the colour; this method was used on the nose and chin, above the lips and under the eyes. To finish off, use a paintbrush and diluted watercolour to paint around the nose, the edge of the lips and to add the spaces between the teeth.

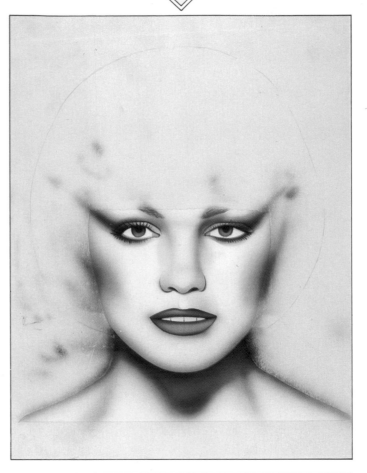

5 Re-mask the face and neck and reveal the hair. Spray the whole hair area flat black and scratch in the highlights with a scalpel. For an added touch of realism, the artist here held a mask along the hairline and sprayed a light shadow on the brow to avoid the effect of the hairline going directly from black to white.

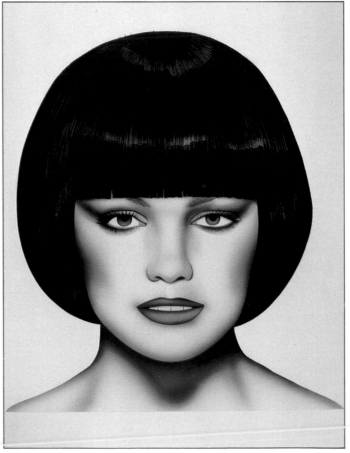

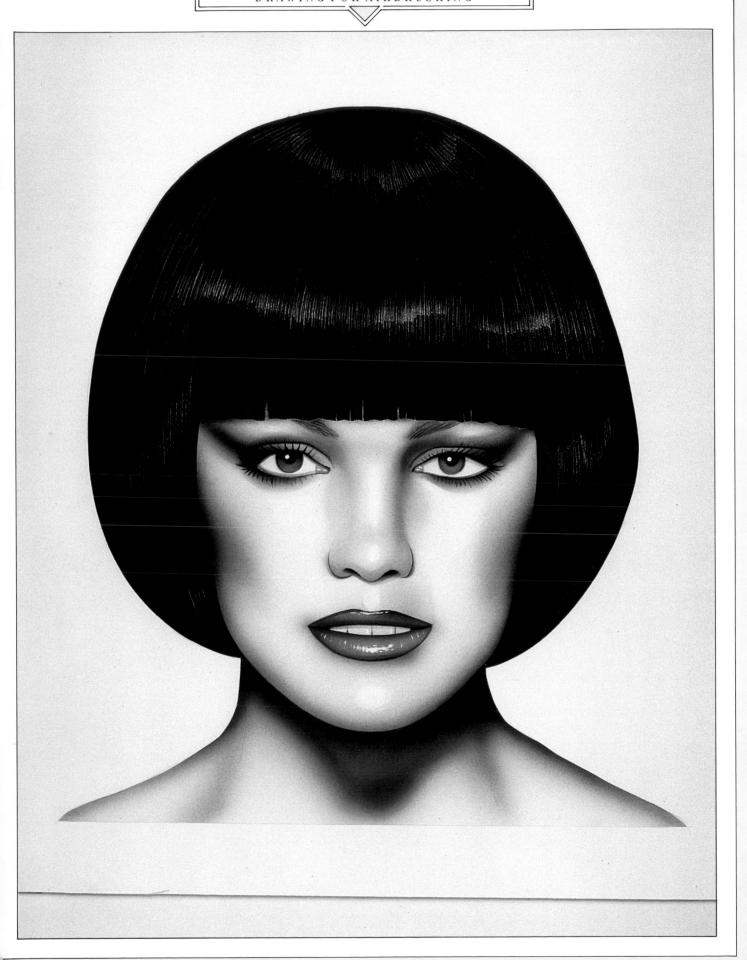

REFERENCES

Some airbrush artists pride themselves on working without anything more than some very vague reference material, but on the whole, most artists invest a lot of time and trouble in the planning stages of their artwork and collect files of ready references.

COLLECTING REFERENCES

References can be collected from many sources. Particularly useful ones are mail order catalogues, holiday brochures and magazines. There are also books of standard reference photographs, showing the human form in every position. These books are invaluable because they show the subtle changes in the human form as it moves and turns, and the differences in posture and movement between male and female and old and young people. A standard reference book may also provide you with new ideas for poses.

PHOTOGRAPHS

Photographs are ideal as reference material and have the advantage of not needing a heavy investment in equipment that will be little used — most people use a camera. An ordinary camera will do, but a motor drive is useful if you want to take a sequence of pictures of the same subject, as might be the case if you were planning to airbrush a cartoon strip with characters based on real people. For this purpose, a photographic record of people taken from different viewpoints and angles would be useful.

Another advantage of using photographs as reference is that if you are going to airbrush in black and white, a monochrome photograph will give you a good indication of the correct shades of grey.

DRAWING UP FROM REFERENCE MATERIAL

Once you have decided on the elements that will make up your picture and where they will be placed in relation to each other, the next step is to draw some concrete references on your support. This can be done in a variety of ways.

GRIDS

The cheapest and simplest way of drawing up a figure

As well as published material in magazines and standard reference books, many artists assemble their own photo-libraries.

Using a grid is a fail-safe of way transferring the original reference to the support. As long as you work carefully, the enlarged or reduced version of the reference that you produce is certain to retain all the proportions of the original. It is easy to change any details in your own artwork — for example, the same girl could appear in the artwork but sitting in a different chair.

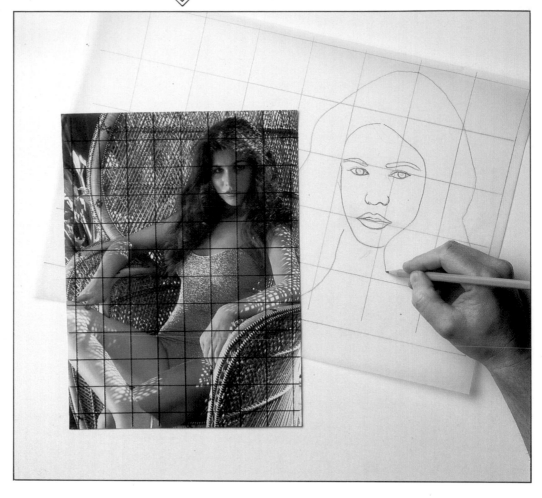

from a reference, without the use of any optical equipment, is to use squared tracing paper or a grid that you have drawn yourself. If you decide to use a sketch of your own as your reference, once the sketch is finished you should draw a squared grid on it very lightly with a soft pencil. A 1.25cm (½in) square grid is a good all-purpose size, but the scale you choose depends very much on the degree of detail you are going to transfer to your support; finely detailed work, for example, will benefit from a smaller-scale grid. It is easier to use the same basic grid size all over the reference, subdividing the more detailed areas with smaller squares which are half the size of the main squares.

Once this grid is completed, you should draw a similar grid on your support, making the squares larger or smaller according to the relative scales of the reference drawing and the finished artwork. Thus, if a reference 30cm (12in) wide is going to become an artwork 45cm (18in) wide, the size of the grid needs to be increased from 1.25cm (½in) square to 1.9cm (¾in) square. The grid on the support should be drawn very lightly so that it can be rubbed off later.

This process can also be used for a photograph or for any other ready-made references. In these cases, it is often easier to trace over the reference, leaving out any unwanted detail. Draw a squared grid on the tracing paper and then transfer the image to your support by reproducing the lines in each original square onto the squares on the support.

It is often helpful to number both the grids, using letters for the horizontal lines and numbers for the vertical ones — this gives each square its own "map reference" which will make sure that the separate parts of the image maintain the same relationship to each other.

If the illustration in the sketch is the same size as the intended finished artwork, the easiest way to transfer one to the other is to trace the sketch, using a medium to hard pencil, on a sheet of tracing paper. Then, turn the paper over and, using a very soft pencil, scribble over the back of the tracing paper. Turning the paper right side up again, lay it in position on the support and go over the sketch with a sharp, hard pencil. This will transfer a faint impression of the sketch onto the support. You may want to go over the lines again to strengthen them, particularly if you are going to spray an opaque medium over the sketch.

PHOTOCOPIES

A modern photocopier that can enlarge and reduce is a useful tool for the creative artist. It means that you can get an instant enlargement or reduction of a reference to the size you want, and do not have to bother with squaring up an

image on a grid. Another advantage is that a montage of images from different sources can instantly be reproduced on one sheet of paper. Black and white copies of a colour original can also help you to reproduce grey tones accurately if your finished artwork is to be monochrome.

An interesting use of photocopiers is that they can photocopy three-dimensional objects placed on the glass of the photocopier, such as necklaces and human hands; often the copy is quite accurate, with little distortion if the original three-dimensional object is reasonably flat.

PROJECTORS

An overhead projector will throw an image drawn on a transparent acetate sheet, onto a wall or screen. The image can be altered or coloured as you wish and the degree of enlargement can be varied by moving the projector nearer to or farther from the wall. If you pin a large sheet of paper to the wall and then project your chosen image onto it, it is a relatively simple task to trace around the image which can later be transferred to your support.

Multiple layers of acetate sheet can be projected simultaneously, giving you a completely free hand with creative special effects.

A conventional slide projector can be used in the same way. (If you hire slides from a picture library, you should check with them that if you sell or publish an artwork based on their slides their charges are not affected.)

Mixing together an image projected from a slide with one from an overhead projector gives you further creative possibilities. This technique could be used to check the result of combining a stylized figure and a realistic background, for example.

PANTOGRAPHS

One very useful but relatively simple method of transferring an image, with almost any degree of enlargement or reduction, is a pantograph. This device consists of a number of pivoted strips of wood or plastic. One part of the pantograph holds a pencil, and another holds a pointer. When the pointer is traced around the image, the pencil produces the same picture. The amount of enlargement or reduction depends on how the pantograph has been set up.

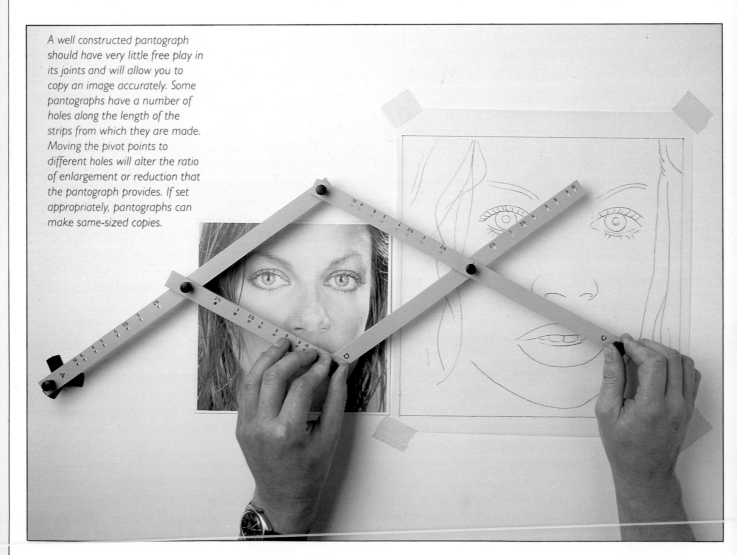

A well constructed pantograph should have very little free play in its joints and will allow you to copy an image accurately. Some pantographs have a number of holes along the length of the strips from which they are made. Moving the pivot points to different holes will alter the ratio of enlargement or reduction that the pantograph provides. If set appropriately, pantographs can make same-sized copies.

Many artists project slides and transparencies in order to trace around the projected image. It is easy to vary the size of the image by moving the projector in relation to the wall or screen.

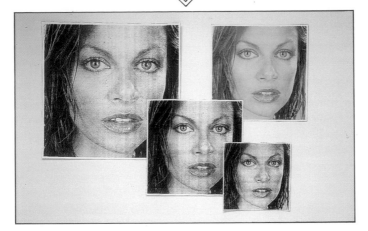

Modern photocopiers which can enlarge or reduce, especially those that can be adjusted over a range of ratios, are useful for re-sizing original references. A little detail is lost every time a photocopy is made from another copy, but the basic proportions remain unchanged, so that they can be drawn back in again when the image has reached the intended size. Most photocopiers can handle paper up to A3 size.

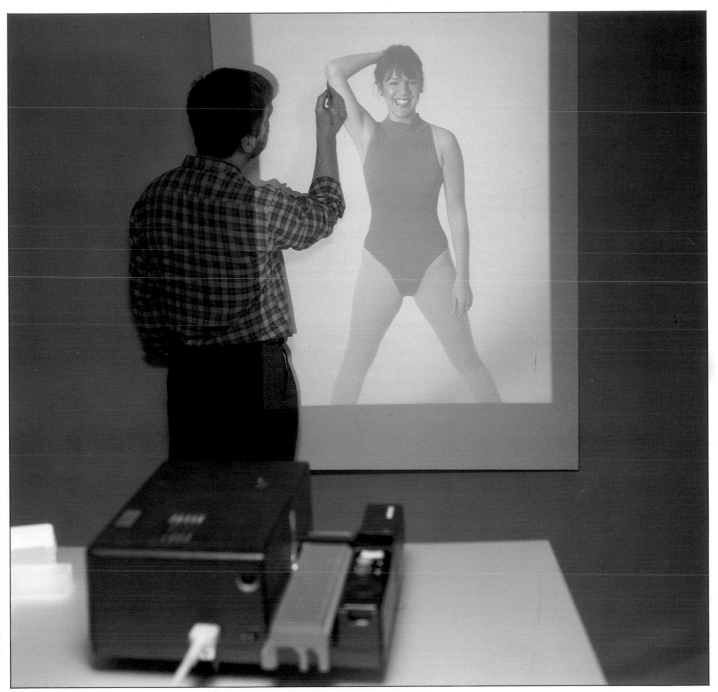

ELEMENTS OF THE HUMAN FORM

SKIN

MOUTHS

NOSES

EYES

EARS

HAIR

HANDS

ARMS AND LEGS

CLOTHING

SKIN

The skin that covers the limbs of a baby or young person tends to be softer and looser than an adult's. Muscular definition is altogether less pronounced and the surface of the skin shows fewer marks and creases. The impression of softness is heightened by the use of delicate colours.

The average person's skin shows signs of weathering and ageing. These processes can affect both the colour and the texture of the skin. With normal muscular development, an adult's limbs show the contours of the underlying muscles but neither the flesh nor the muscles will be taut.

Even when the skin has a darker tone, it is still important to show the areas of light and shade which give the artwork its impression of volume and form. Well-developed muscles need to have clear outlines so that they stand out prominently from the surrounding flesh.

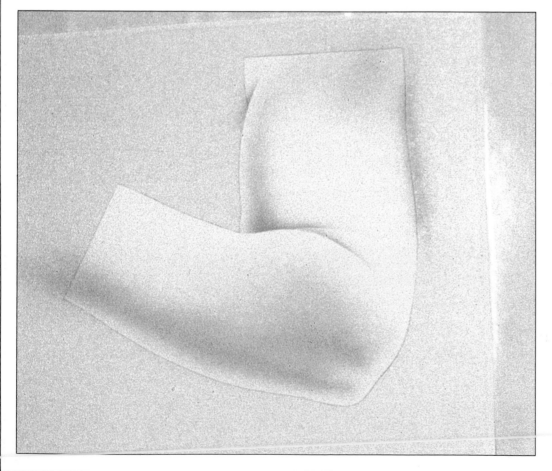

1 Here the artist continued the gradual accentuation of the shape of the arm by spraying sepia watercolour freehand. The process amounts to little more than light toning, because a heavy spray of colour would destroy the soft, light look that is essential for realism.

2 *A baby's skin often has a warm, almost glowing, appearance. The skin colour was added by airbrushing a mixture of permanent red and yellow ochre. There is only a light spray of sepia underneath the flesh tone, and so the resulting colour appears as a peach pink.*

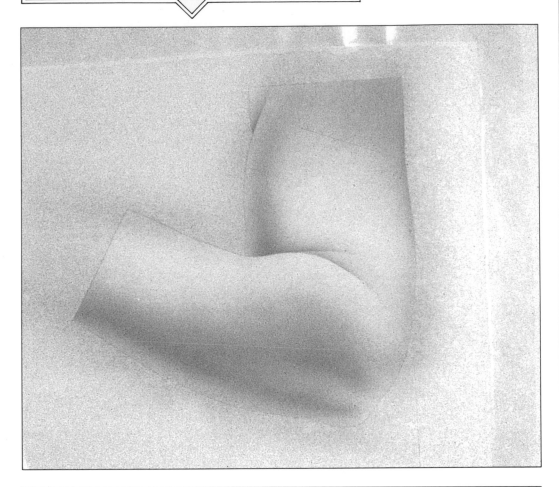

3 *After the masking has been peeled away, there is an opportunity to correct any small imperfections in the artwork. It is best to resist the temptation to sharpen up any of the edges of the artwork with a brush or a pencil, as this would spoil the "soft" feel.*

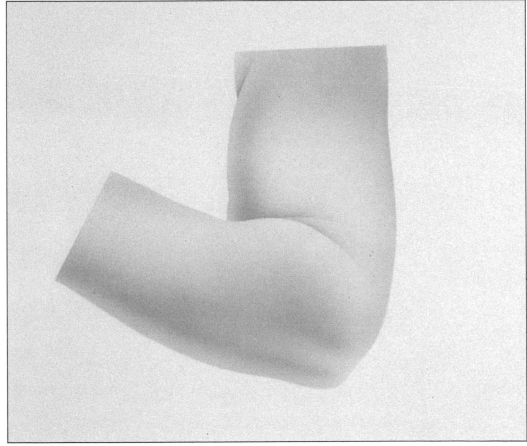

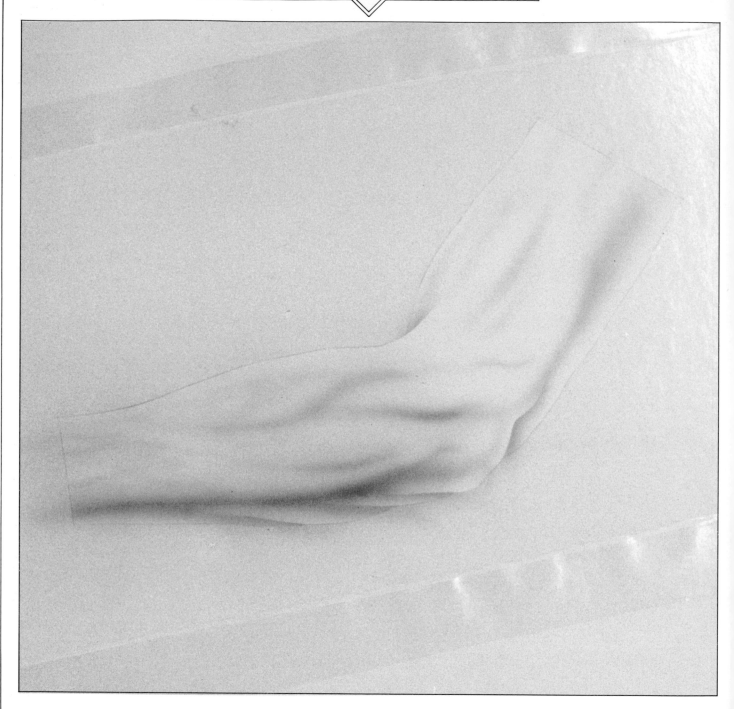

1 The shapes within the outline of the arm have softer edges, allowing them to be airbrushed freehand. The artist used a sepia watercolour to create these shapes. There is also a little blue watercolour on the forearm, to show that the veins are near the surface, and on the elbow where the skin is tightly stretched by the bone.

2 The arm now requires a flesh colour to make it look more natural. This was mixed from yellow ochre and permanent red watercolour. For an extra touch of realism, the artist sprayed more colour onto the forearm so that it would appear tanned in contrast with the pale upper arm.

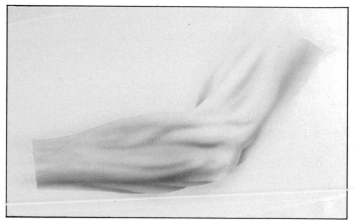

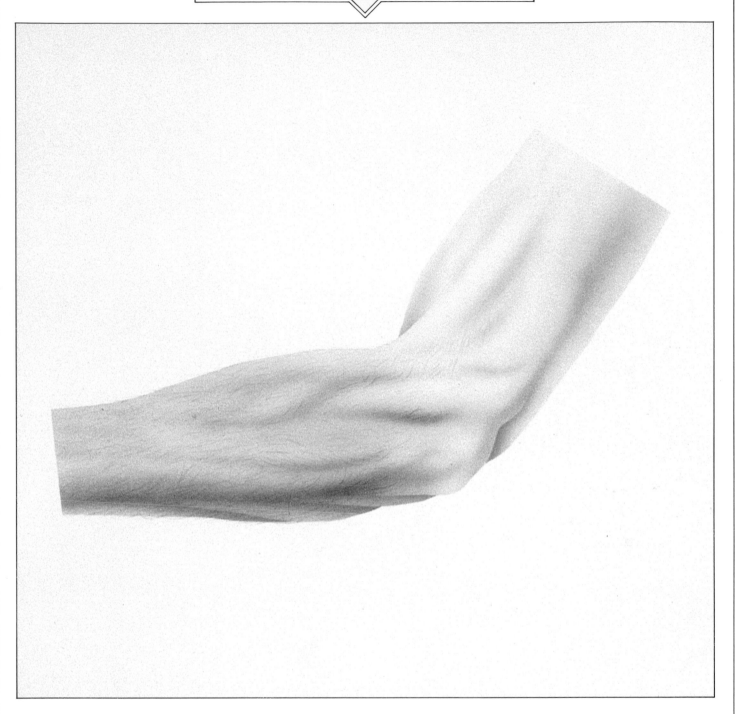

3 *The airbrushing is now complete. When the mask has been removed you can blow away any specks of colour that fall onto the board. For an additional realistic touch, the artist used a sable brush to add some fine hairs to the forearm. Any colour that has bled under the mask can be removed with a scalpel.*

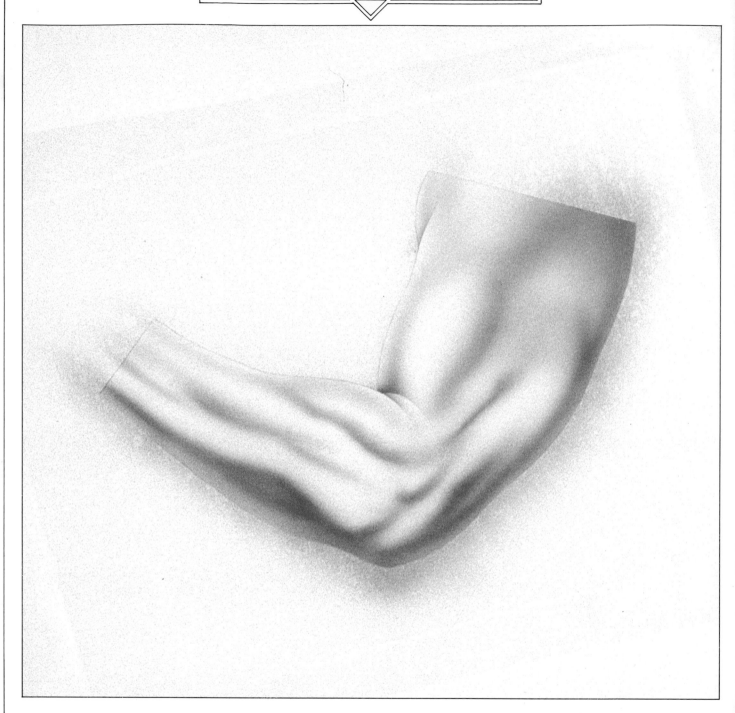

1 *There are no sharp edges within the outline of the arm, so it is easiest to airbrush freehand, strengthening the contours of the muscles and the shade of the skin. It is best to spray away from the dark areas towards the lighter ones, gradually intensifying the darkest parts of the arm.*

2 *A wash of flesh colour, airbrushed over the sepia, gives the arm a lifelike look. The muscular impression is heightened by spraying the flesh colour more heavily around the edges of the muscles so that the centre of the arm is lighter and shows up as a highlight, indicating that the skin is stretched tight.*

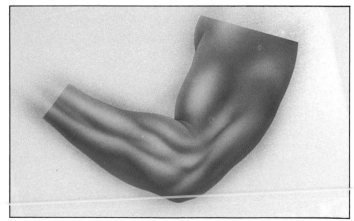

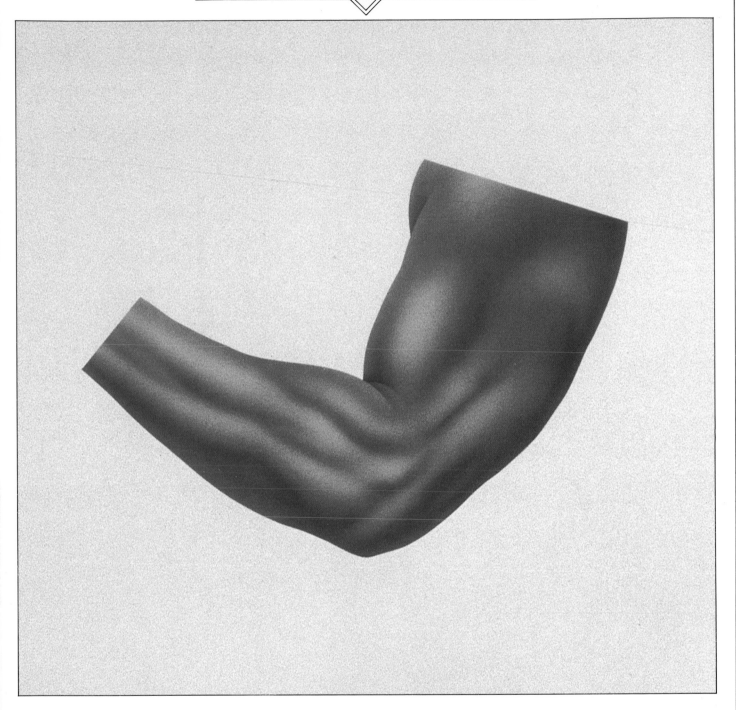

3 Strip away the masking and clean away any stray specks of paint from the board. You may wish to sharpen some of the dark edges of the muscles or bones; use a very fine sable brush for this but take care not to make your lines too thick or the artwork may become a caricature.

A person's age, sex and ethnic background are all revealed to a lessor or greater extent by his or her skin. Close attention therefore needs to be paid to texture and skin tone for the finished artwork to look convincingly real.

1 When portrait-like realism is required, it is important to match the range of tones in the model's skin. In this example, the lighter areas of skin were sprayed in watercolour. Because watercolour is transparent, the colour of the support tends to show through. By using an eraser to cut back the colour, the artist adjusted the flesh tones for a lifelike effect.

2 The original photographic reference for this artwork was taken with a fish-eye lens, which gives a distorted image. The illustration was first airbrushed in black and white, using diluted ink. Then the eyebrows were sable-brushed and the highlights were scratched in. Finally, colour was added — sky blue and purple for the face, red for the lips and orange for the eyes.

3 This illustrtion shows clearly the results that can be achieved with hard masking. A combination of frisket and acetate masks was used for airbrushing the water on the girl's back. If soft masking, such as tracing paper, had been used, the artist would not have been able to delineate each droplet of water so precisely.

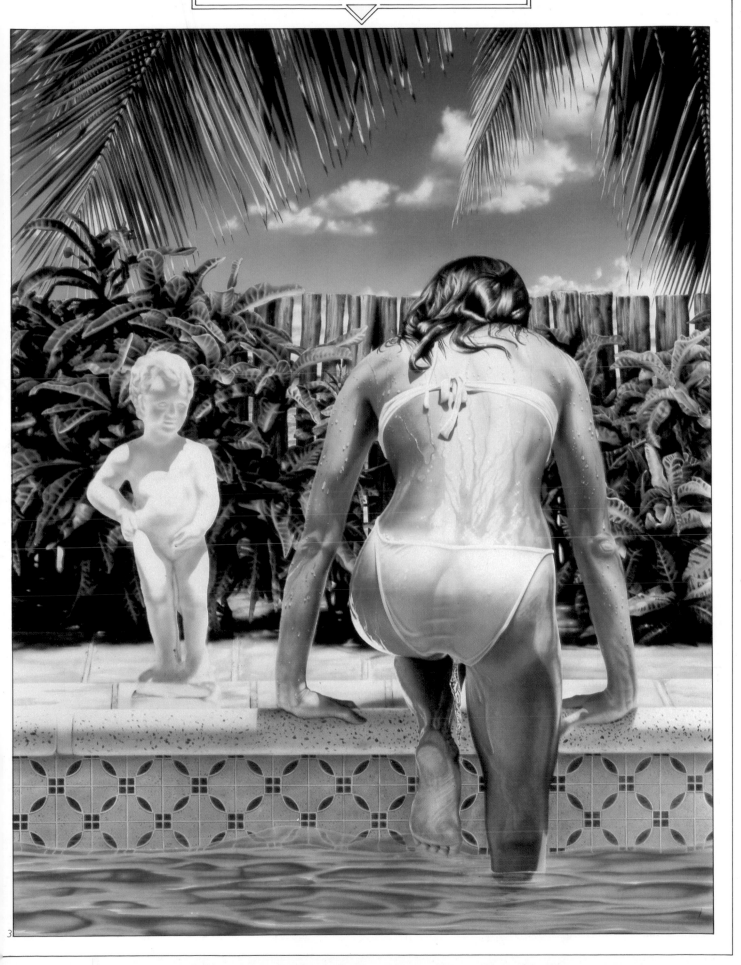

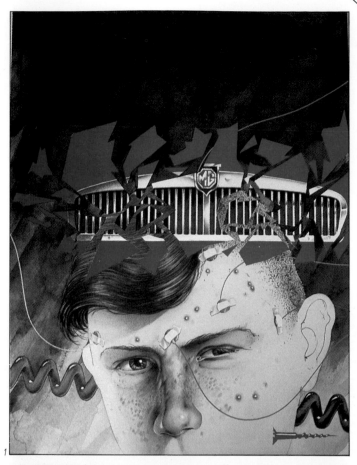

1 *You may not often want to portray teenage acne, but the technique is worth knowing anyway! Here, each spot was sprayed freehand with a quick burst of colour. Then, a coloured pencil was used to add definition. The dark areas around the nose were shaded in with a sable brush, the final details being added with coloured pencils.*

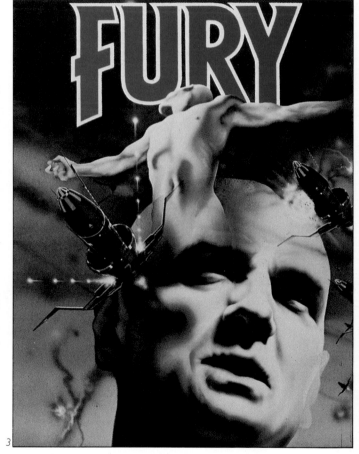

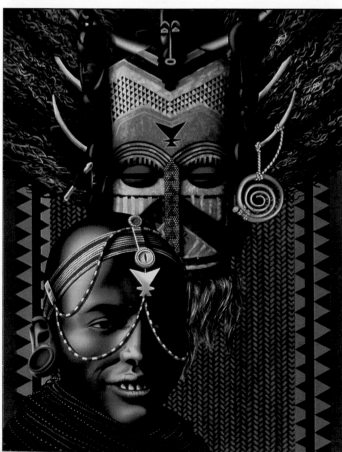

2 *For this photorealistic study, the artist used a combination of masking film and loose tracing paper masks. The basic colours of the face were airbrushed in ink and then small adjustments were made in gouache with a sable brush. The tones of the girl's skin required a variety of shades, ranging from light burnt sienna through dark brown to black.*

3 *The wide range of colours present in this face were airbrushed in ink and gouache. The colour was built up in several layers, with paper masks used to enhance the soft, fleshy look of the man's skin. After each spraying, the colour was rubbed back with an eraser and then strengthened again by further airbrushing until the right balance had been achieved.*

4 This study of Dizzy Gillespie was largely airbrushed in ink, although the artist used coloured crayons to create some of the details and texture of the hair. Soft masks were used for most of the areas of the skin, allowing freehand airbrushing to build up the colours. The skin tones owe their richness to a combination of orange and sepia inks.

5 Boy George's blusher and make-up were rendered in pastels. to achieve the same effect, rub a pastel stick on a piece of paper then blot the paper with cotton wool. You can then dab the artwork with the cotton wool in order to transfer the powdered pastel colour. If the resulting colour is too strong, careful use of an eraser will cut it back.

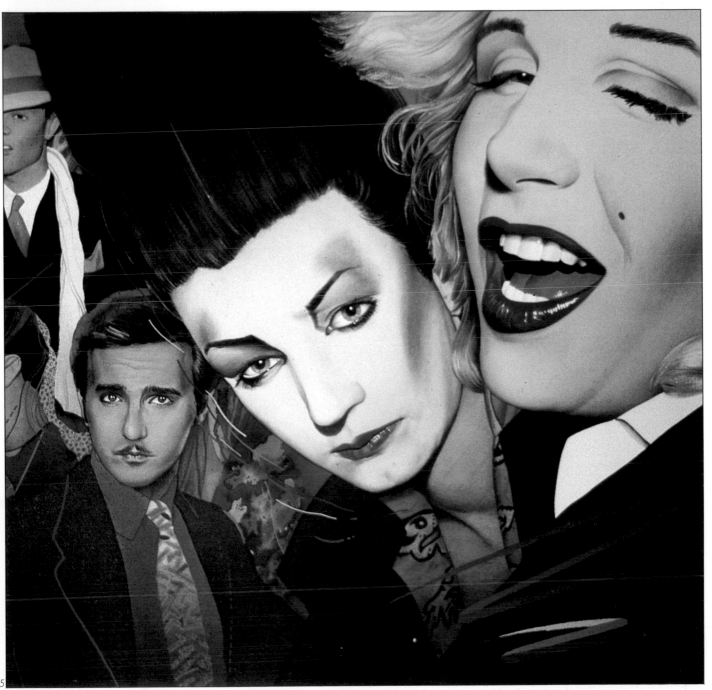

MOUTHS

The texture of lips is unlike the skin on any other part of the human form, and special attention is needed to make it look realistic. Similarly, teeth have a unique texture and individual colour. They are never perfectly smooth and white and if you paint them like this they will not be convincing. However, you can deviate from reality without destroying a portrait's authenticity – for example by adding colour and gloss to lips, for a touch of glamour.

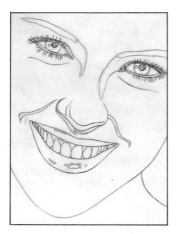

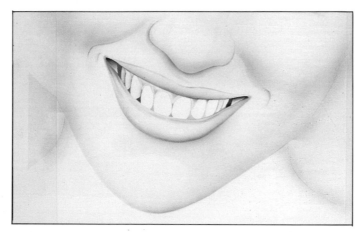

2 Dilute quasar black ink with water to make a mid-grey colour. Cut separate acetate masks for the top and bottom lips and spray the grey towards the edge of the masks to create the basic shapes of the lips. The gums and the dark areas in the corners of the mouth need their own separate masks, as does the shadow that falls below the lower lip.

1 The initial pencil drawing on tracing paper shows the basic shape of the mouth, teeth and gums. There is a highlight on the lower lip as well as highlights for the teeth, which can be painted in later. If your reference does not show the teeth clearly, check the number and spacing of real teeth by looking at your own or someone else's.

3 The next stage is to spray a flat layer of diluted flesh poster colour over the whole area. Don't worry about the teeth; their whiteness will be restored next.

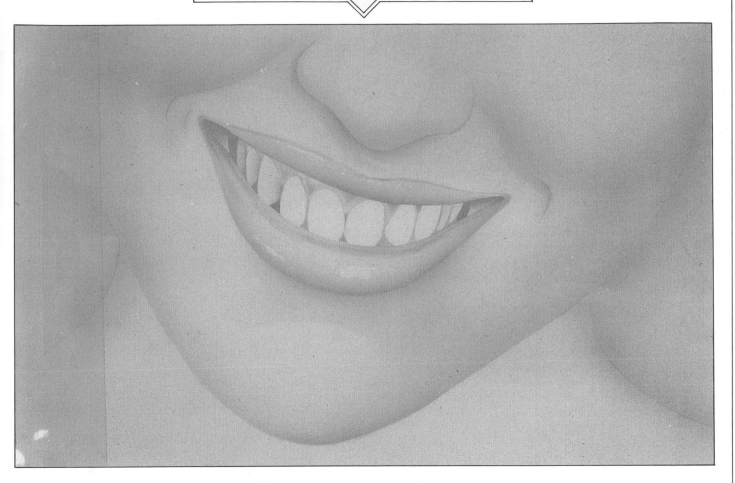

4 *Dilute some white gouache, and cut acetate masks for the teeth. Spray a flat layer of white across the teeth, referring constantly to the reference for guidance as to the correct colour. The flesh colour will still show through the white, and it may be tempting to overwhiten the teeth, but don't; teeth always pick up reflections from the flesh of the face, which mutes their whiteness.*

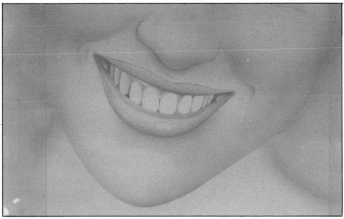

5 *In order to add some shape to the mouth and to give greater definition to the teeth, more white highlights are needed. Cut small masks and carefully spray more white onto the gums and the skin beside the mouth. These highlights should not be overemphasized, or the teeth will look dull by comparison.*

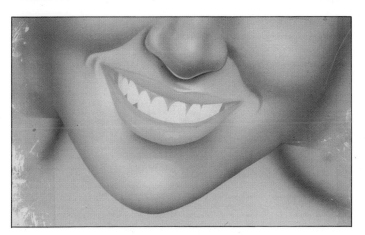

6 *Now cut two masks, one for each lip, and a separate mask for the gums. Holding the masks down tight against the paper or board, spray vermilion deep over the lips. Referring to the original reference, add pure white highlights with a sable brush. The highlights should follow the texture of the skin.*

7 Here, the white highlights are rather harsh, so to soften them the artist cut acetate masks and then sprayed diluted white gouache over the painted highlights. Use white gouache and a fine sable brush to paint highlights on the teeth themselves. Then spray more white highlights onto the gums.

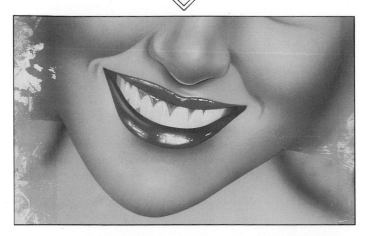

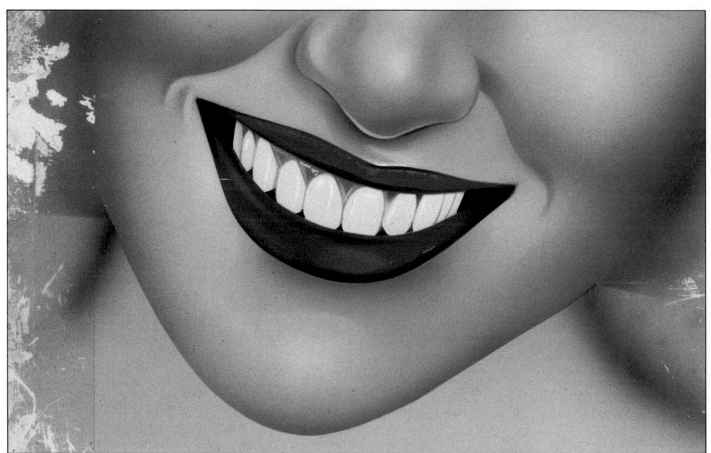

8 In real life, the lines between the teeth are never black. Spray dilute vermilion deep over the lips and also over the lines between the teeth. Adding a touch of red in this way gives a more realistic and natural look to the whole mouth

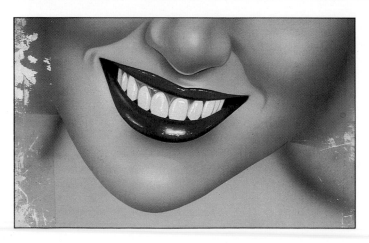

9 The mouth can now be given more definition. Mix equal quantities of vermilion deep and ivory black. Carefully cut masks for the mouth so that the dark dividing line will be thicker at the front of the mouth and thinner at the edges. Here, small triangular masks were used to create the dark areas in the corners of the mouth. These details make the lips stand out from the face.

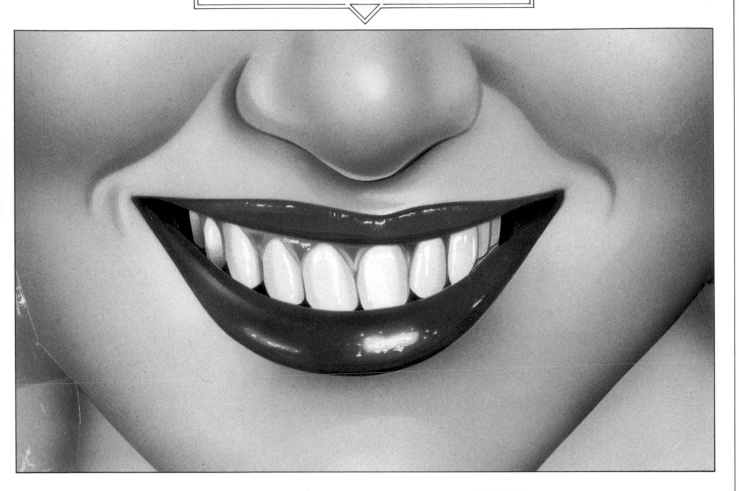

10 The white highlights that were applied earlier on have been softened by the vermilion deep, so they should be restored at this stage. Diluted white gouache will allow the red tints to show through, creating a natural shade. Use acetate masks for the broader areas of highlights and paint in finer highlights by hand with a sable brush.

11 The last stage is to add the final shape and highlights to the teeth. Dilute ivory black to make a light grey shade. Cut acetate masks for the teeth and spray around the edges of the teeth so that a natural convex shape is created. Finally, paint fine white highlights on the teeth with a brush. Make the shape of these highlights slightly irregular or else the teeth will have an unrealistic, "machine-made" appearance.

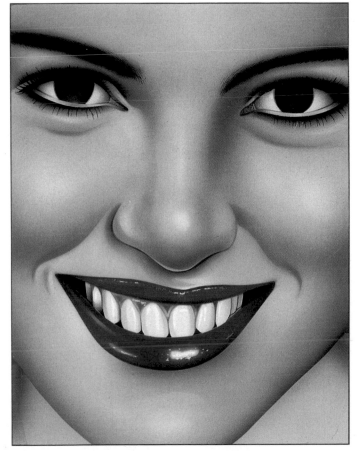

NOSES

O f all the features of the face, the nose presents special problems to the artist because, unlike the mouth or the eyes, it has no definite boundaries unless it is viewed directly from the side. By delineating its contours and with careful shading it is possible to give it volume and form, yet it should still blend with its surrounding features so that it does not look as if it has just been stuck on to the face.

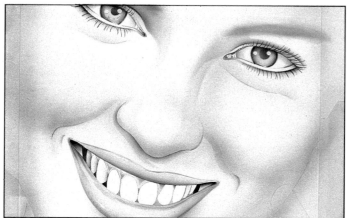

1 The initial, detailed sketch shows all the areas of the nose that will be emphasized in the finished artwork. At this stage, it is best to exaggerate the outline of the nose as a guide to the areas where you will be spraying, but don't be alarmed by this a lot of the lines which you draw will end up as smooth gradations of tone rather than clear divisions between different areas.

2 The first colour to spray is quasar black diluted with water to make a mid-grey shade. Be careful, and apply only a light spray or else the nose will look too dark in the finished artwork, which will give it excessive prominence. The final shape of the nose will be delineated by the grey shadows around it.

3 Now spray flesh poster colour over the nose and surrounding area. The poster colour used here was diluted with water to about the consistency of creamy milk. It is important to adjust the density of this layer of colour correctly – if the artwork is to represent a person with a fair skin, only a light spray will be required.

4 The nose begins to take shape when the highlights are added, with white gouache. Cut masks for these highlights, from a sheet of acetate. Use a long shape for the bridge of the nose and a separate, circular shape for the highlight on the tip of the nose. It is important to cut the highlight areas bigger than the eventual highlights so that the surrounding colour can be graded and blended up to the final, smaller highlights.

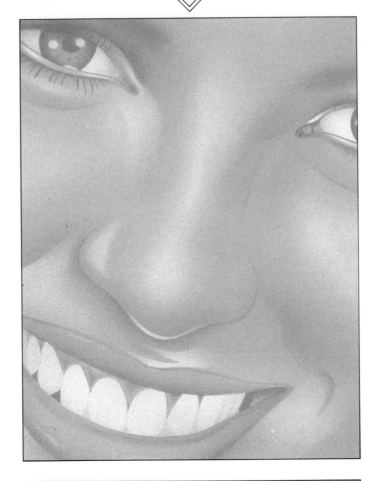

5 The contrast between the flesh colour of the nose and the white highlights can be reduced by spraying over the nose once more with flesh poster colour. Diluting the poster colour with water produces a softer flesh tone. The highlights on the nose now appear as a lighter flesh colour rather than the unrealistic white tone that was sprayed originally.

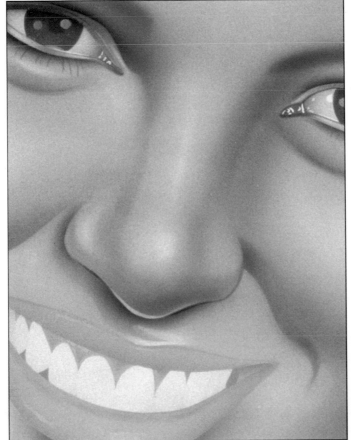

6 To add volume to the nose, create a shadow at its base. The artist here first sprayed a little black at the base of the nose. Using an acetate mask, he then added Vandyke brown gouache at the base of the nose and also slightly above this area to give the effect of a grey shadow showing through the brown. This shadow now makes the nose stand out from the face.

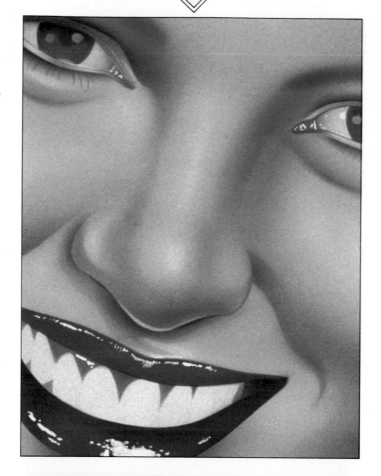

7 Great delicacy is needed for the next step. Dilute some vermilion deep gouache with water and spray it very sparingly over the whole of the nose. The resulting slightly red tone brings the nose forward. If too much vermilion is applied, the nose will be unrealistic and unflattering.

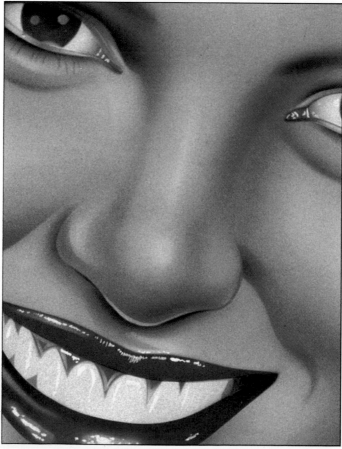

8 *To restore the brightness of the highlights, cut a long mask for the bridge of the nose and a round one for the tip. Make these masks slightly smaller than those in step 4, so that the highlight becomes progressively brighter towards the centre. It is advisable to look at the original reference at this stage to ensure that the highlights conform with your intended result.*

9 *For the darkest shadows, mix some Vandyke brown and ivory black together and spray it carefully under the tip and at the sides of the nose. Also spray a small shadow on the tip of the nose. Using a fine sable brush and the same mixture of colours, paint a thin line around the edge of the shadows. This final line adds a little more definition to the nose.*

EYES

Of all the features of the human form, it is the eyes that tell us most about the person. For the airbrush artist, the eyes give the opportunity to show the character of the person in the illustration. For instance, sharply defined eyes looking straight out of the picture will create an impression of alertness and vigour, whereas a softer shading in the eyes will give the face a gentler, more relaxed look.

1 Make a pencil drawing on tracing paper, showing all the details that will form the eyes. Don't worry if some of the details, such as individual eyelashes, are so small that you cannot cut a mask for them, because such small areas can easily be painted in with a sable brush.

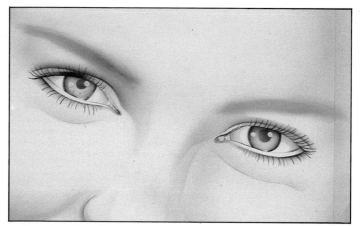

2 Cut acetate masks for the eyes. The artist here used quasar black waterproof ink at this stage because it will not run when water-based gouache is sprayed on top. A sable brush was used for the individual eyelashes. The shading around the eyes helps to give volume to the eye sockets.

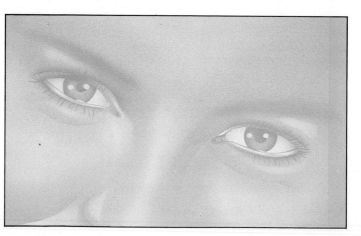

3 Spray a flat layer of flesh poster paint over the face. Even though you will later add white to the eyes, the flesh colour underneath will show through the white slightly to give a more life-like appearance. In real life the eyes rarely contain pure white, and even the whitest eyes pick up reflections from the rest of the face.

4 Cut acetate masks for the whites of the eyes and for the highlights in the iris and pupil. Hold the masks down firmly against the board to give these areas a hard edge. The masks for the highlights around the eyes should be held away from the board so that the colour fades out gradually at the edges of the sprayed areas.

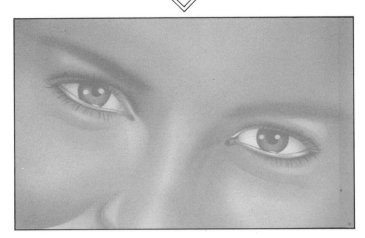

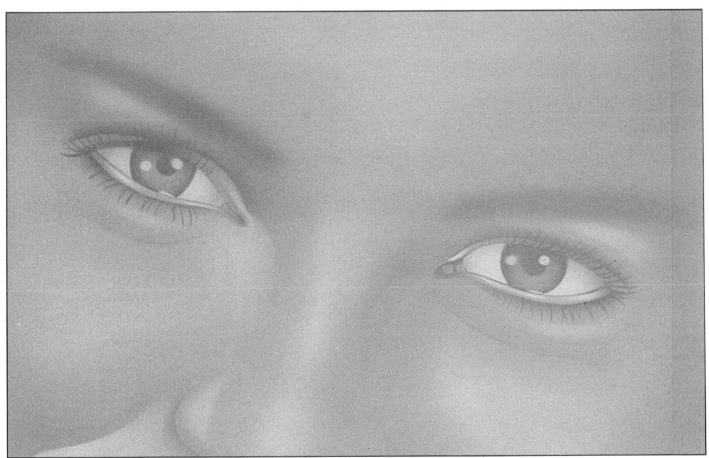

5 Spray over the eyes again with flesh poster paint. This additional colouring reduces the contrast between the whites of the eyes and the skin of the face, and also restores a realistic flesh tint to those highlights that were previously white.

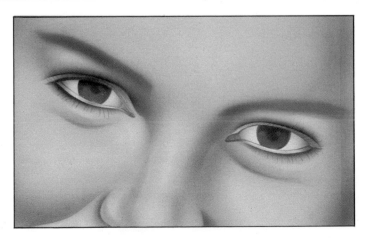

6 For brown eyes, add a more natural colour with Vandyke brown gouache. Cut a new mask for the pupil and the iris, and make masks for the eyebrows, the lines around the eyes, and the shading around the eyes. The white highlights in the iris should be emphasized by spraying white over the Vandyke brown, and further highlights should be added in the corner of the eye.

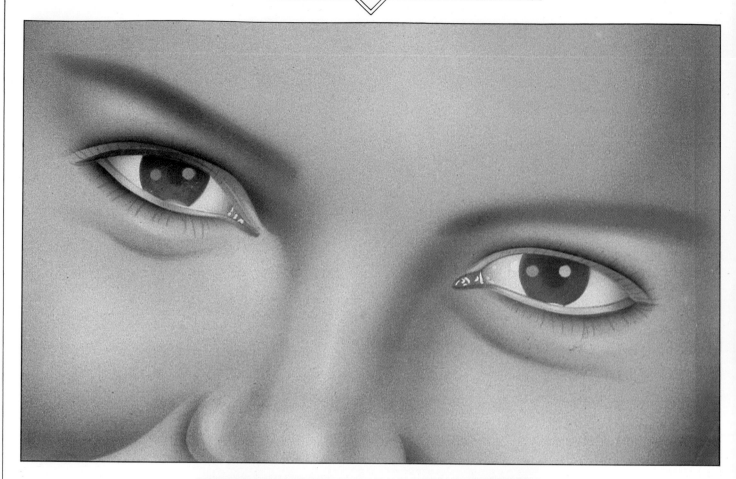

7 *The eye will look more realistic if it contains some red, because the blood vessels in eyes give them a tinge of red. Vermilion deep gouache is the ideal shade. Spray small areas in the corners of the eyes and then lightly over the white of the eye to give a pale red tint.*

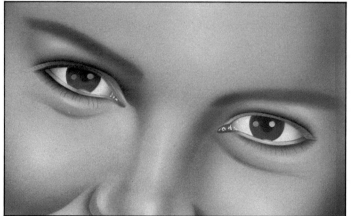

8 *By this stage, the eye has probably lost its brightness. To restore the eye's natural white colour, cut acetate masks and spray white onto the eyeballs and those areas of the iris that are to be highlighted.*

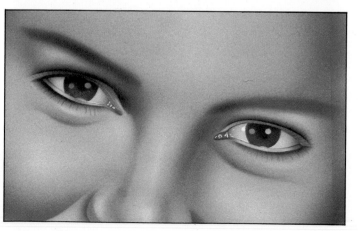

9 *For the pupil and the iris, use a mixture of equal parts of Vandyke brown and ivory black. Cut one acetate mask for the pupil and one for the iris. Add the mascara around the edges of the eye and spray some shadows around the eyelid. Check with your original reference for guidance on shading and intensity of colour.*

10 *At this stage apply ivory black to the pupil and iris and on the eyelash and eyebrow. Once you paint these and the shadow of the eyelid, the eye will become more realistic. Spray a little vermilion deep in the corner of the eye.*

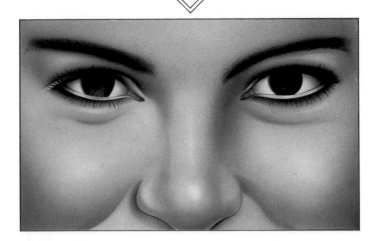

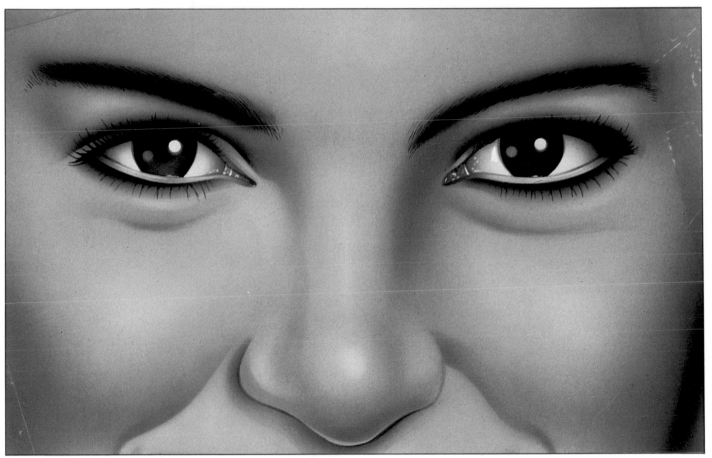

11 *Finally, add the highlights. The main one is over the pupil and there is a secondary highlight in the iris. Here, the artist used a sable brush to paint the tiny highlights in the corner of the eye and along the line where the eye meets the lower eyelid.*

12 *With masking removed the artwork of the eye is now complete.*

EARS

Unless you wish to portray ears with complete photo-realism, it is often possible to simplify the details of the ear to prevent it from dominating a face shown in profile. The tones of the ear can vary from a whitish shade on the rim of the ear to a dark, almost black colour inside.

1 *The intial drawing should contain all of the details of the ear that will appear in the finished illustration. The direction of the light falling on the ear can affect its three-dimensional appearance, so bear in mind that an ear lit directly from the side will show fewer shadows, leading to a flatter effect.*

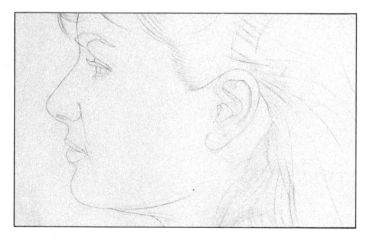

2 *The drawing was masked with Frisk film to reveal the darkest areas. Using sepia watercolour, the artist then sprayed both these areas and the sharpest edges on the rim of the ear within the folds of the ear itself.*

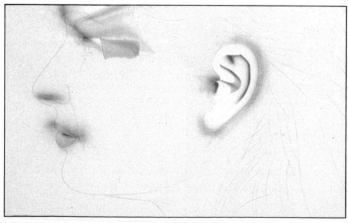

3 The lighter areas of the ear come into play in the next stage. Using the same dark sepia watercolour and spraying very gently, the contours of the ear are developed. Careful freehand use of the airbrush will intensify the darker portions of the ear and blend them in smoothly.

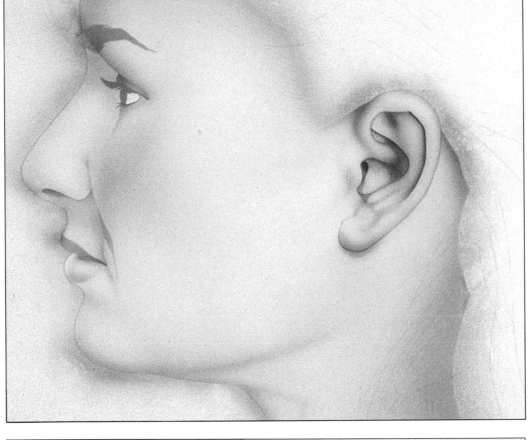

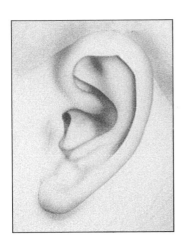

4 The ear begins to look more natural when a wash of flesh colour is sprayed over the sepia. A mixture of permanent red and yellow ochre watercolour gives an appropriate shade. The flesh colour should be diluted so that the details of the ear will still show clearly through the flesh tone.

5 When the colours of the ear have been fully developed, it is time to reinforce the hard edges of the folds inside the ear and around the rim using a fine sable brush and dark sepia watercolour.

Women's mouths especially offer the artist a wide scope for creating colour and texture. Even the artful use of cosmetics cannot achieve the effects possible with an airbrush!

2 The solid red colour of this mouth was airbrushed in ink, the artist building up the intensity of the colour with repeated applications. Some detail was added in pencil and the dark line where the lips meet was painted with a sable brush. A scalpel is ideal for scratching through the colour to give the highlights on the lower lip; spraying over the white highlights in red gives a more natural pink shade.

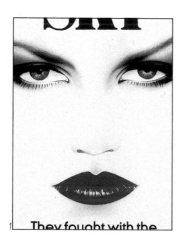

1 Sometimes, there is no photographic reference available which is exactly right for the artwork you wish to create. Everyone's face is slightly asymmetric, so that a mouth drawn from real life may appear unattractive if it is portrayed in the centre of an image. The artist avoided this pitfall by tracing half the mouth, reversing the tracing paper and then tracing the same half again to give an exactly symmetrical mouth.

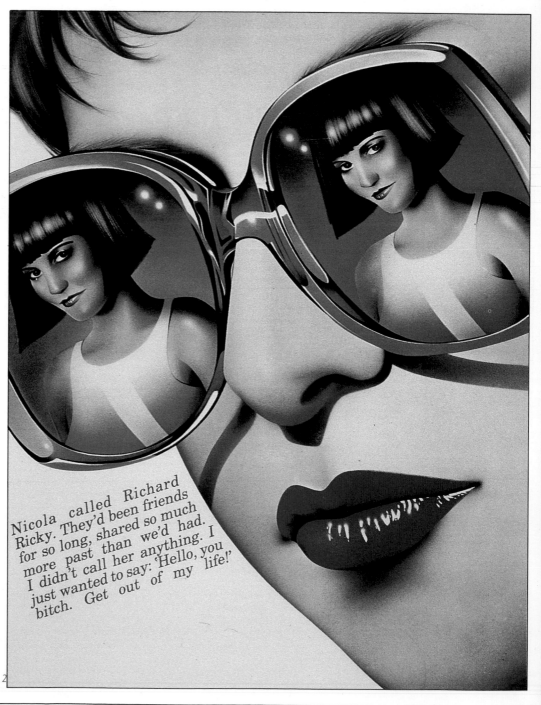

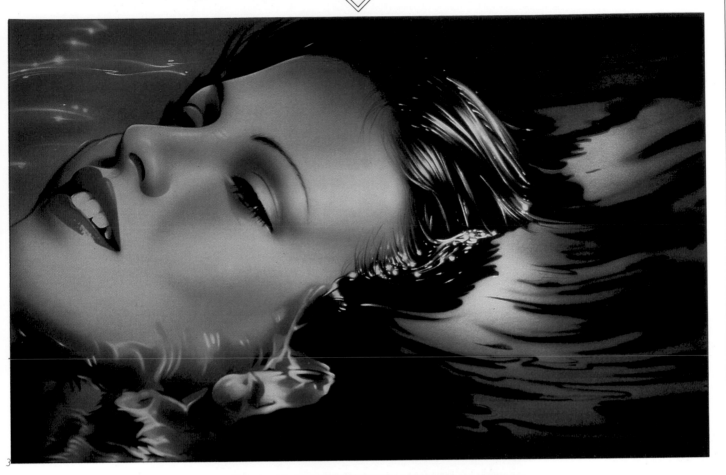

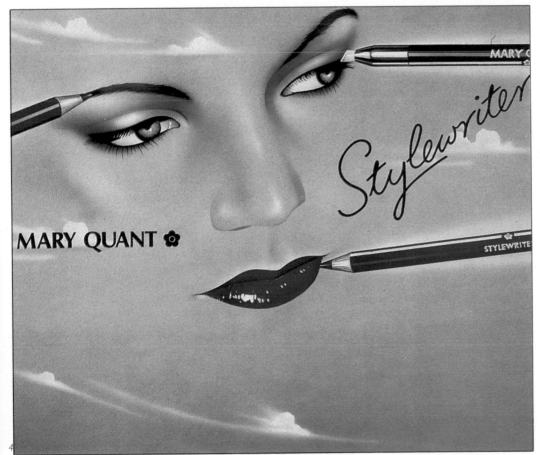

3 Unless you particularly want to draw attention to a figure's teeth, it is best to understate them in your artworks. The basic shape of the teeth needs to be right, but often, as in this example, you can let the mouth do most of the work. The whiteness of the teeth comes from the support showing through the surrounding colour. A light wash of pink over the teeth makes them appear less conspicuous.

4 The unnatural colours and blurred shape of the face give this artwork a surreal appearance. A wholly natural mouth would have looked out of place, and so the artist has created a stylized, glossy mouth. The use of hard masks gave the mouth its sharply defined edges and the bright highlights accentuate the sheen of the lips. The absence of a chin also makes the lips appear more striking.

To look lifelike, particularly if it is seen in close-up, the eye requires a surprising amount of detail. The small flecks of colour on the iris and the reflections on its surface, for example, all need to be incorporated into the artwork.

1 Much of the power of this image comes from the brightness of the eyes. The artist used hard masks to give the pupils and irises their sharp definition. The fine details were added in pencil and then white paint was used for the highlights. The stylized quality of the artwork allowed the artist to leave the whites of the eyes free of the veins and yellow hues characteristic of real eyes.

2 For this illustration, the artist created all of the details of the eyes by airbrushing, using ink as the medium. The highlights in the eyes show how the eye's rounded shape reflects light from many directions. The eye will reflect the original source of light falling on it, for example, a window, as well as other details such as the eyelashes and the colour of the model's clothing.

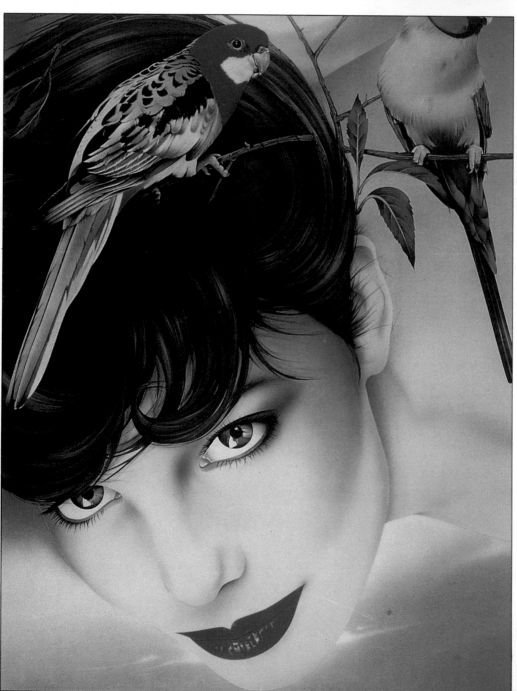

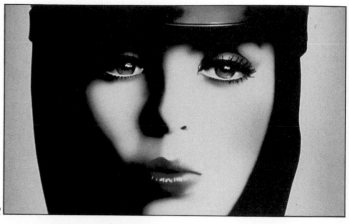

3 This highly stylized eye is a visual pun on the theme of "private eye". The whole of the black central area and the circular white highlight were masked ready for the pupil to be airbrushed. Then, all of the small white segments of the iris were individually rubbed back with a hard eraser to let the whiteness of the support show through.

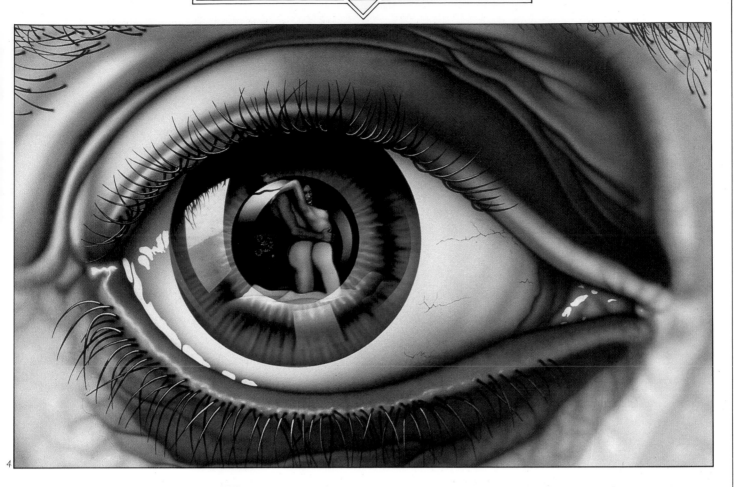

4 *By showing the eye in this extreme close-up view, the artist was able to include a lot of fine detail. The basic airbrushing was carried out in gouache and dye, but there is a considerable amount of sable brush work, as well as some coloured pencil, in the modelling of the eyelashes and the skin around the eye.*

5 *Here, the striking emerald colour of the eyes was created in ink, and then eyeliner was applied with a sable brush. The eye shadow was airbrushed against soft, tracing paper masks, held a little above the support so that a soft edge was formed. A fine sable brush is ideal for applying the white highlights which give eyes their sparkle and bring a face to life.*

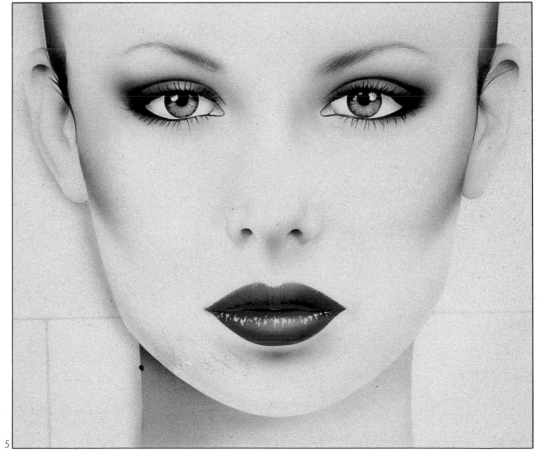

Because the eyes are the features of the face that naturally grab the viewer's attention, the nose and ears are sometimes relegated to secondary importance. They should, however, be given their fair share of attention if the face is not to look unbalanced or if a sideview has been chosen which emphasizes their proportions.

1 Most of the airbrushing on the nose in this example was achieved with the aid of soft masks which enable the gently rounded contours of the nose to be represented accurately. The dark area of the nostril, however, was sprayed through a hard mask to sharpen up its edges. The shadows around the nose are all-important if the nose is to appear natural and realistic.

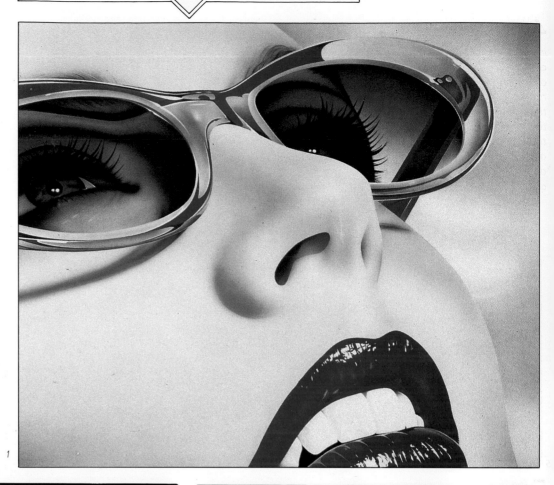

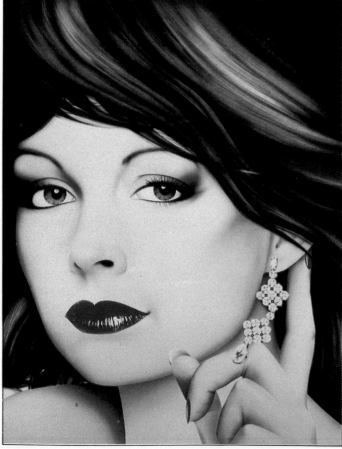

2 The flesh tones in this image were sprayed in ink. The transparent nature of ink allows underlying colours to show through. The darker colours were sprayed first and then adjusted with an eraser, where necessary, to reduce the intensity. It is easier to correct any light-coloured overspray on the darker areas than vice versa, so the light colours are best left until last.

3 The artist worked on this image one section at a time in order to heighten its "collage" appearance. The lines around the individual sections were emphasized when all of the masks had been removed. Much of the detail around the nose and ears was added with a sable brush and water-soluble coloured pencils applied on top of the airbrushed base colour.

4 When the face is shown in profile, it is especially important to shape the nose correctly — you can easily make a beautiful model look ugly if the nose is wrong. For this illustration, the artist masked the whole of the nose and the ear to define their outlines, and then airbrushed freehand to create the details of the nostril and the curves of the ear.

5 The "science fiction" feel to this image meant that the ear could be stylized, with exaggerated shapes and colours. Using paper masks, the artist first airbrushed watercolour sienna to give the underlying shade. Then scarlet was sprayed over the sienna to create the glowing tones of the finished artwork.

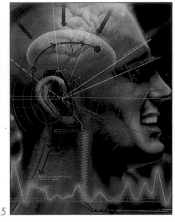

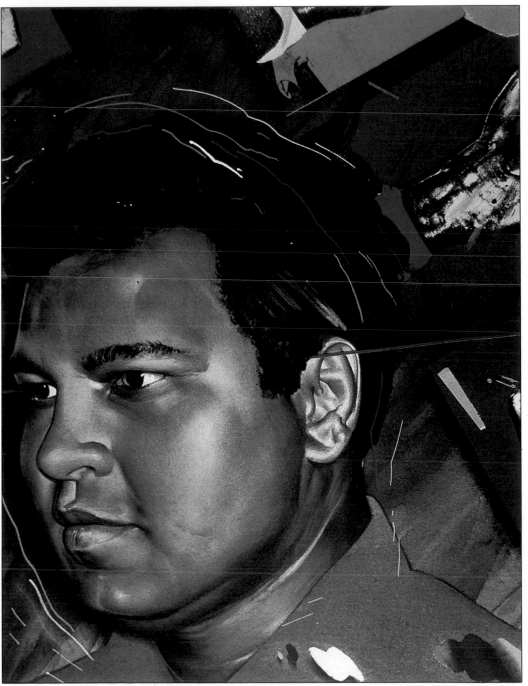

6 The overall tone of Muhammad Ali's skin was laid down in watercolour — a mixture of burnt sienna and umber gave the correct result. The fine modelling of the ear and nose was added in blue pencil over a brown watercolour base to give a remarkably lifelike image.

HAIR

The approaches that the artist can adopt when air-brushing hair are as numerous as the hairstyles that can be portrayed. In this sequence, which is basically monochrome but includes a range of shades, the examples include both long, flowing hair and loose, spiky hair.

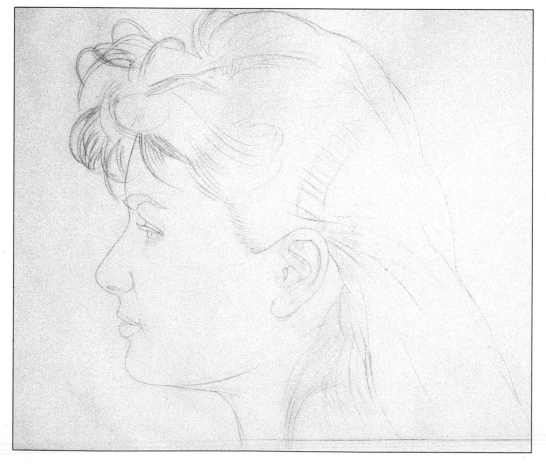

1 The original pencil drawing of the hair divided the whole head of hair into dark, medium and light areas. Following the principle of working from dark to light, the artist first masked all the hair then revealed the dark areas and sprayed the initial wash of grey watercolour.

2 The hair gradually takes shape as the different shades are emphasized. When the medium and light areas are progressively revealed and sprayed, the hair begins to look more flowing. As you spray the lightest sections, overspray will fall onto the other parts of the hair and make them appear darker.

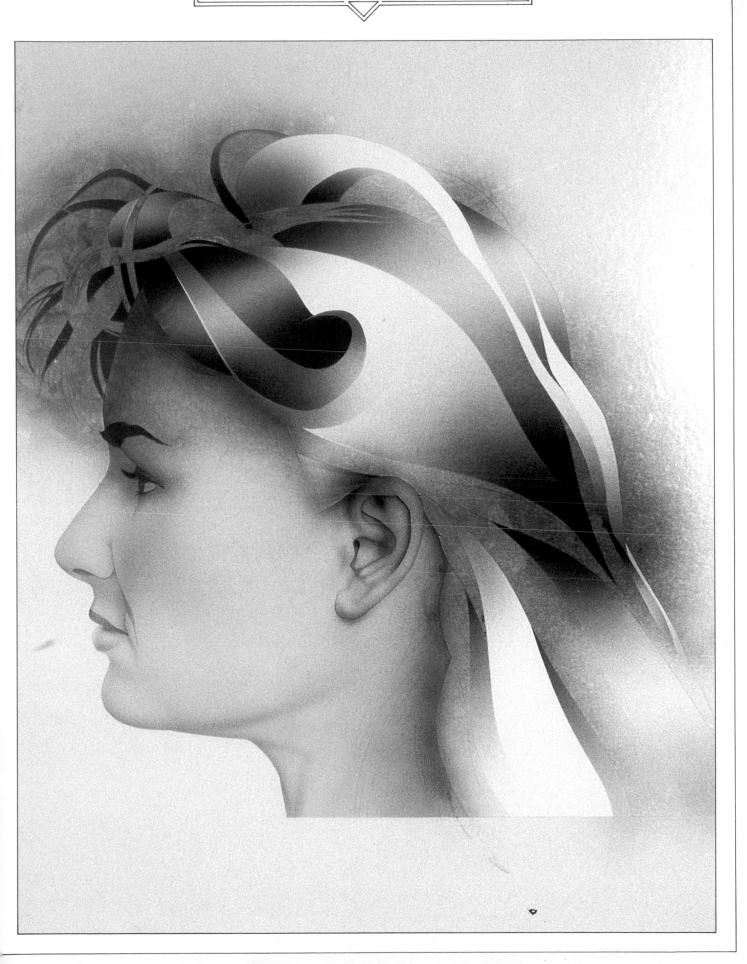

3 Add more detail to the hair by spraying lines between the strands of hair. Accentuating these details gives the hair a fuller, glossier look. Refer to your original reference to check that the amount of detail is correct. If the highlights are too regular, the hair will develop an artificial look.

4 Continued freehand application of grey watercolour gives body to the hair and removes any hard edges between the different shades. It is best to airbrush a very fine spray, building up the colour gradually, because it is much easier to add colour than to remove it.

5 Once the masking has been taken off, you can add any small details that are required. In this example, a white pencil was used for the highlights above the ear; the loose hairs on the neck were drawn with a pencil; and some of the edges around the outline of the hair were softened by freehand airbrushing.

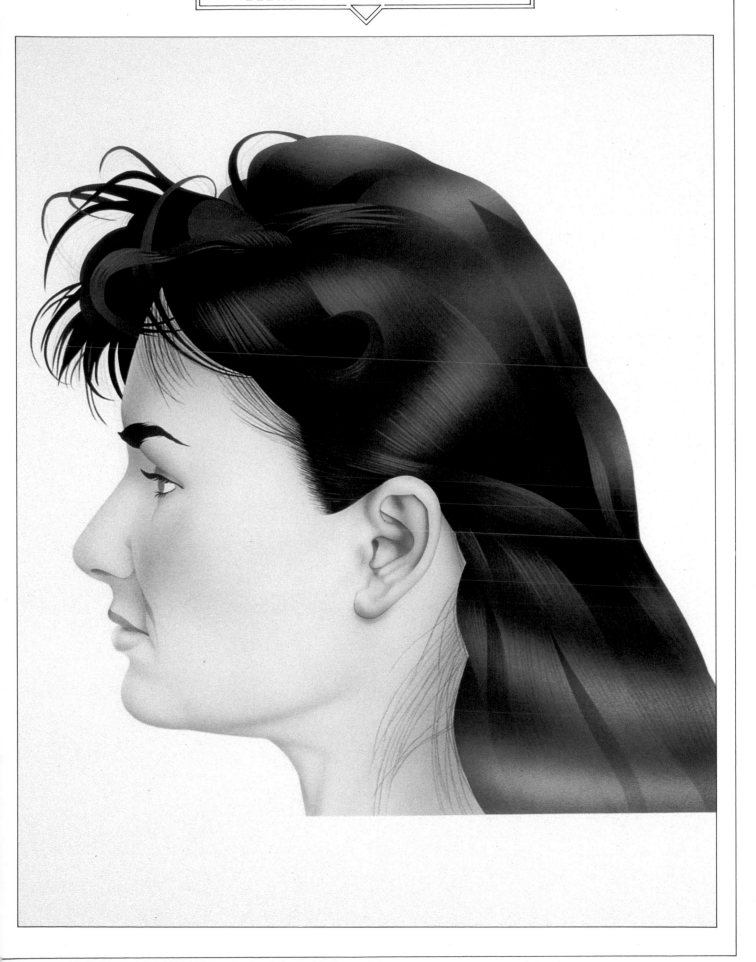

The wide diversity of hairstyles in real life is the starting point for the artist's imagination. The hair can be anything from a small detail to a multi-coloured 'crowning glory'.

2 In this artwork, the artist has aimed for a slightly stylized appearance. He used tracing paper masks, held just above the support, to allow a little of the colour to spread under the mask. This gives a softer edge to the different areas of colour in the hair. The highlights were cut back with a scalpel and then oversprayed.

1

1 For this study of Debbie Harry, the artist used hard masks in order to make the strands of hair appear sharp and well defined. Some of the detailing in the hair was added in pencil. Note how the heightened colours in Debbie's face accentuate the pale shades of her hair; the colours used to spray her skin include crimson, burnt sienna and yellow.

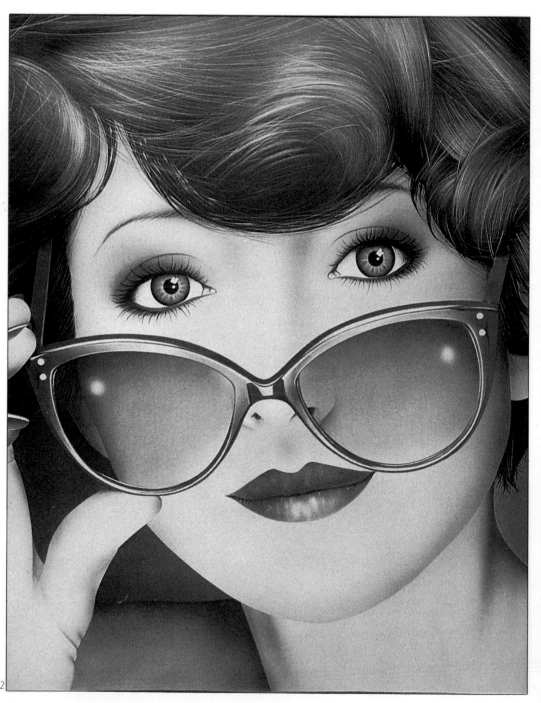

2

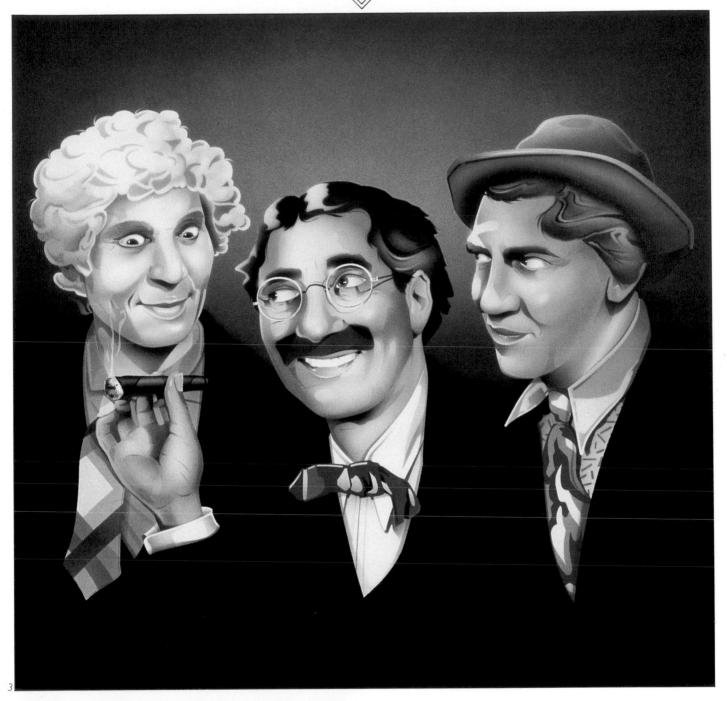

3

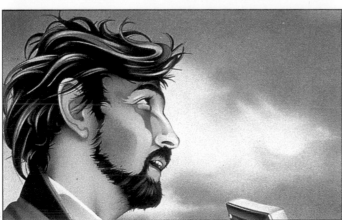

4

3 Unlike some of the other examples in this section, this portrait of the Marx Brothers is all airbrushed — no work has been done with a scalpel or sable brush. Loose tissue paper masks were used to give the slightly soft edges to the hair. Note how pure airbrushing can produce any texture from Harpo's natural-looking curls to Groucho's sleek and glossy hairstyle.

4 The man in this image was intended to have a rough, uncouth look. Hard masks were used for the hair to give sharp definition between the different tones in the hair. Some of the darker parts of the hair were sprayed with a mixture of brown and blue. The roughness of the beard was emphasized by using a hard pencil on top of the airbrushed colour.

1 The highlights in Diana Rigg's hair were scratched out with a stencil knife — this is not as sharp as a scalpel and the angle of the point is not as acute. By controlling the knife carefully, the artist produced curved, sweeping effects. Different degrees of shading are possible by varying the pressure on the stencil knife as it moves across the support.

2 Careful use of an eraser can give finely graded shading to airbrushed hair. In this example, the whitest areas of Sidney Greenstreet's hair have been rubbed back with a hard ink eraser. Where the white areas merge into the greyer parts of the hair, a softer pencil eraser has been used to feather the edges and blend the shades.

3 Some of the details of the girl's hair were sable-brushed and then an airbrush was used to complete the area. The multicoloured effect which the artist wanted meant that it was not possible to blend two colours together to achieve the shading that exists in natural hair — the colour in the airbrush therefore had to be changed several times so that the full range of colours could be sprayed.

HANDS

O f all the elements of the human form, hands are probably the most difficult to portray realistically. If you are seeking to depict natural-looking hands, it therefore pays to spend a large proportion of time on the original drawing, either tracing from an existing reference or sketching from life.

1 *The original drawing shows the outline of the hand and also the areas where the details of the flesh will appear. The drawing was carried out on detail paper and then transferred to the board once it was finished to the artist's satisfaction. This is perhaps the most important stage — any mistakes in the original drawing will be carried through to the finished artwork.*

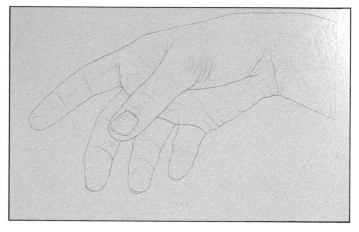

2 *The artist then masked around the outline of the hand, because these edges need to appear sharp in the finished illustration. The thumb also was masked at this stage because it will be developed separately from the rest of the hand. The first colour was then sprayed, concentrating on the areas of flesh which will appear the darkest.*

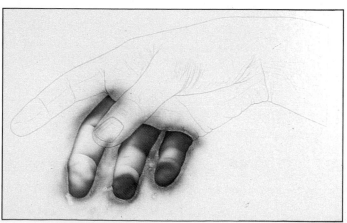

3 *The next step is to continue the gradual build-up of colour on the hand. The medium in this example is dark sepia watercolour. The artist sprayed freehand, using the underlying drawing as a guide, to give more volume to the underside of the fingers. The colour on the thumb is actually on top of the mask which covers the thumb.*

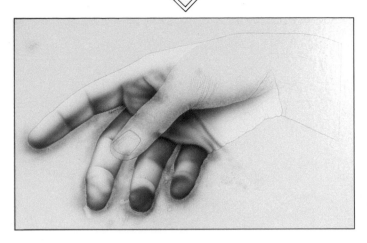

4 *The thumb nail requires special attention because it is in the foreground of the illustration. Once the mask had been removed from the thumb, the artist cut another mask for the thumb nail, so that the nail would have clearly-defined edges. He then airbrushed the nail freehand, building up the intensity of colour to add a sense of solidity to the nail.*

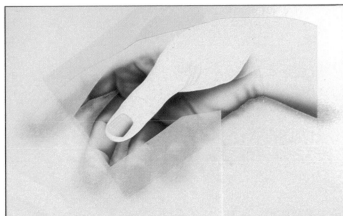

5 *The process of developing the form of the hand continues. At this stage, it pays to refer constantly to the original reference so that the details of the hand will be faithfully reproduced. Most of the pencil guidelines drawn on the board will now have been covered with water colour, and so mistakes are liable to creep in unless great care is taken.*

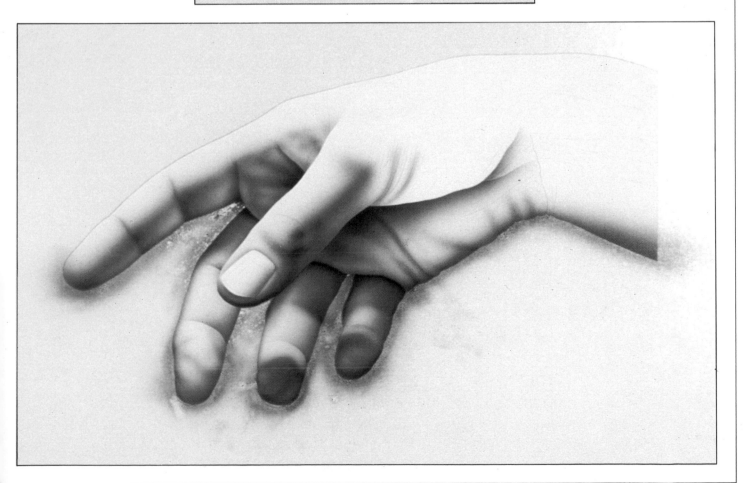

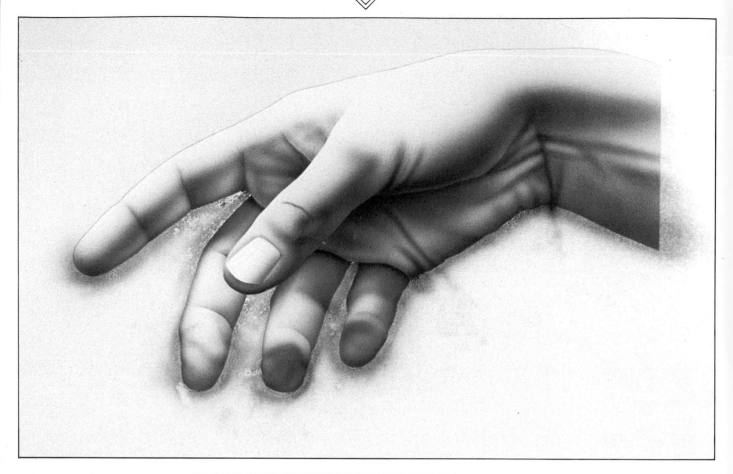

6 Adding the details of the palm of the hand and on the forearm really brings the artwork to life. Again, this is done by freehand spraying. The diluted watercolour used here gives only a light covering of colour — it may take five or six passes with the airbrush to intensify the colour in the darkest areas, such as the shadow beneath the thumb.

7 A second colour on top of the sepia gives a more natural look to the hand. This shade is mixed from yellow ochre and permanent red watercolour. The darker tone underneath will show through the flesh colour to give a sense of form. Spray only a light wash of flesh tone at first because a too-heavy spray will be difficult to correct.

8 The flesh-coloured part of the nail was developed separately and sprayed so that the lighter tip of the nail would remain prominent. The process of building up the flesh colour continued on the forearm and on the thumb. The hand now appears as a unified, realistic illustration with a more natural skin colour.

9 *A second wash of flesh colour will give the skin a armer tone. The mix of this colour is slightly different from the first shade - there is more yellow ochre and less permanent red, to give a peach shade. A light spray of this shade will correct the skin tone; refer to your reference to make sure that the final colour is absolutely right.*

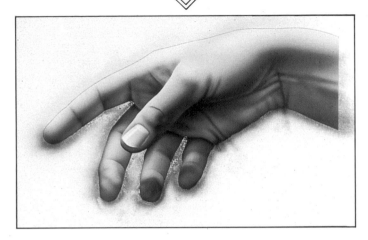

10 *Any final details can now be added with a sable brush. Using a dark skin tone, carefully brush in any creases in the skin and strengthen any areas which need to have firm definition, like the knuckle on the thumb. Whilst the hand is still masked, it is still possible to go back and correct any details that are not quite perfect.*

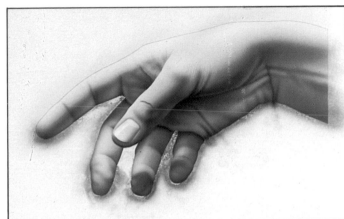

11 *Make sure that the artwork is absolutely dry and then carefully remove the mask. Some flakes of watercolour will probably fall onto the board as you take the masking away, but you can blow them off with the airbrush. If the colour has bled under the mask, use a scalpel blade to scrape the unwanted colour away, working away from the edge of the hand.*

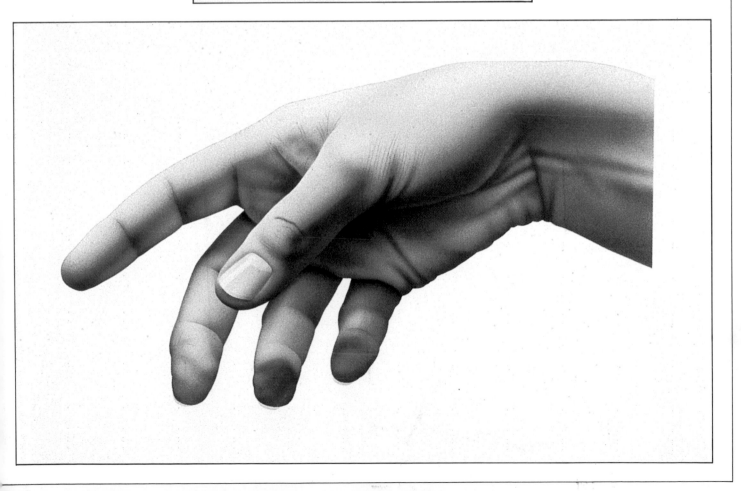

A person's hands can be almost as expressive as the face. Hands that are relaxed convey a sense of calm, but tense, clenched hands immediately suggest anxiety or aggression.

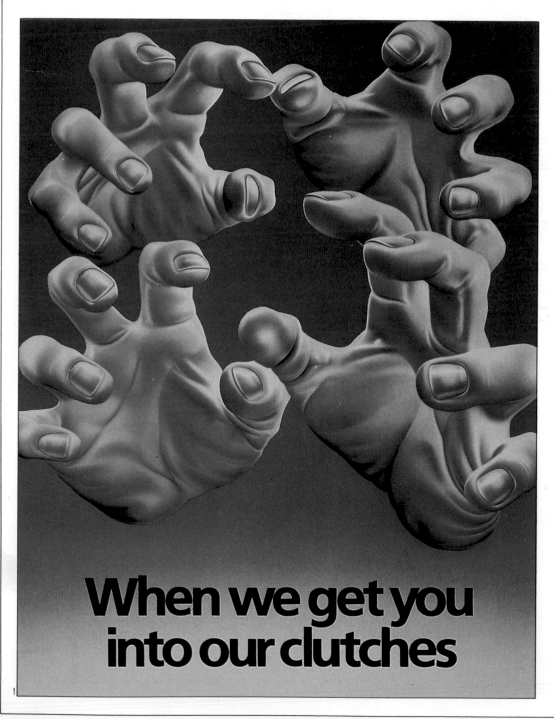

When we get you into our clutches

1 No suitable reference was available for this illustration and so the artist asked friends to pose as models. The colour is all airbrushed apart from some details on the nails which were drawn with pencil crayons. Paper masks were cut for the creases on the palms of the hands, and the highlights on the knuckles were rubbed back with an eraser.

2 This hand was rendered in watercolour — almost all of the hand was airbrushed, with only a small amount of detail added using a sable brush. Note how the areas of shadow around the fingers are sharply delineated, but that the shadow around the inside of the thumb merges into the blackness of the background. The highlights on the nails suggest that the hand and the camera are illuminated by the same light source.

3 This illustration was sprayed in acrylic inks, to give the rich, strong colours that the image required. Acrylics dry very quickly and so are ideal for an artwork like this one which contains a broad spread of tones, ranging from the silver of the talons to the black of the shadow areas and the joints of the fingers.

4 In this example, the basic colour of the hands was airbrushed in acrylic. Then, the different tones were emphasized by rubbing back the acrylic with an eraser. A scalpel was also used to scratch away the colour. After the tones had been adjusted in this way, the artist used the airbrush to reinforce the colours where necessary.

5 *It can be difficult to match the colour of hands, even when using a flesh-coloured medium. In this illustration, the artist sprayed a wash of blue, then added an overall spray in a flesh tone. Next, the details of the back of the hand and the fingers were scratched away; a final all-over spray restored the appearance of smooth skin.*

6 *This example was completely airbrushed in ink. The artist has maximized the effectiveness of the chrome by setting the hands against a dark background. The red, orange and yellow tones suggest that coloured lights have been used to illuminate the scene. Note also the way that the reflections of the black and white keys have been picked up by the palms of the hands and the fingers.*

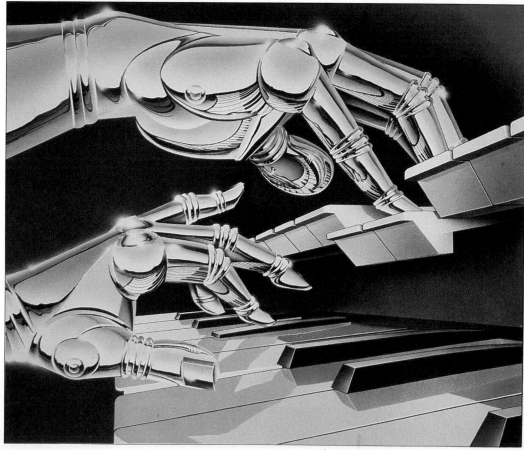

7 *For this example, the artist imitated the style of a Victorian lithograph. To simulate the texture of stone, a low-pressure spray was used. The colours were airbrushed in semi-waterproof transparent ink; the original colours were slightly darker than the finished artwork but were rubbed back with an ink eraser. A small amount of overspraying added the final touch to the colours.*

8 *An unusual technique was used to create the gradations of tone on the back of the hand in this example. The artist first sprayed the base colour, which was kept moist by airbrushing a gentle wash of pure water. Detail was then added with coloured pencils and a sable brush. This technique needs great restraint, or the colours may run.*

ARMS AND LEGS

The arms and legs are important parts of the figure because their position tell us a lot about the subject's mood and character. Although the basic contours and proportions of the feet and legs need to be correct, you can often take liberties with details such as prominent veins and ugly toenails in order to produce a more flattering result.

1 *The initial drawing shows all the detail that will be present in the finished artwork. Because the model is brightly lit by sunlight, there will be a wide range of tones between the highlights and shadows, with the darkest area of shadow falling where the legs touch and between the fingers. Quasar black ink sprayed over the drawing gives volume to the figure.*

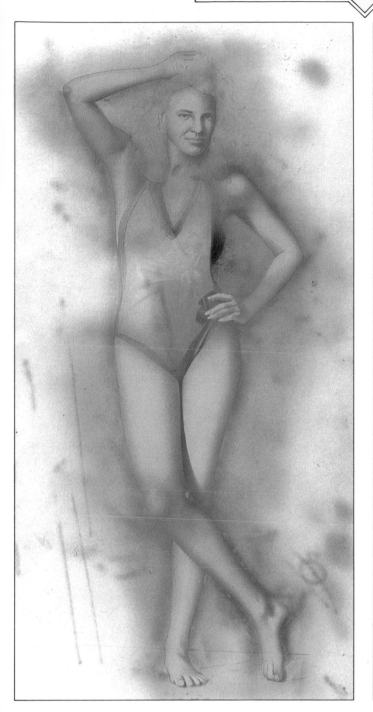

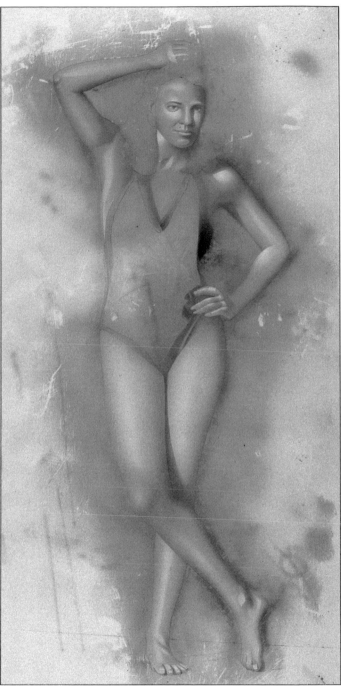

2 The impression of solidity is heightened when a flat layer of flesh colour is sprayed over the legs and arms. This initial layer of colour should be finely controlled so that it does not completely obscure the detailed sketch underneath. The blackness of the shadows sprayed in the previous stage has now been muted to give a more natural look.

3 The highlights in the arms and legs are unusual because the range from the smooth, soft highlights on the thighs and forearms to the much harder highlights on the ankles and knuckles. In both cases, the technique is the same — cut a mask slightly larger than the size of the final highlight. A layer of white gouache begins to bring the legs and arms to life by accentuating their curved forms.

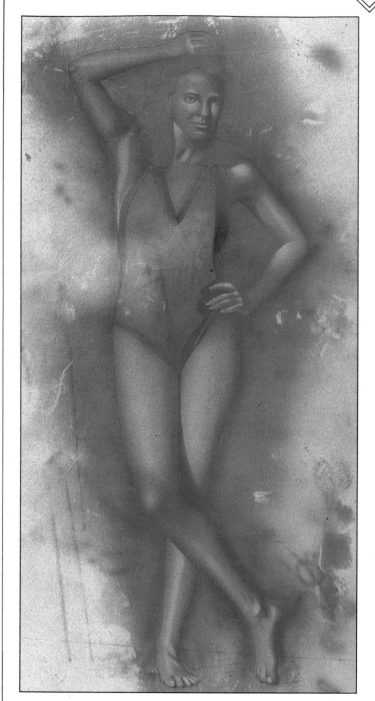

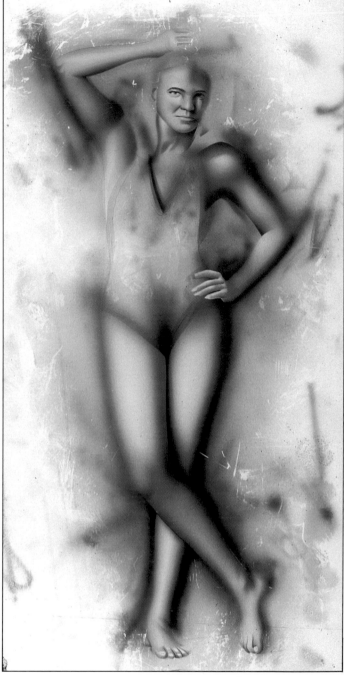

4 Even though this figure is brightly lit, the highlights should not appear as pure white in the finished artwork. To reduce the intensity of the white gouache, spray once again over the whole of the arms and legs with flesh colour. The highlights will now appear as lighter-coloured flesh tones set against the less brightly lit areas.

5 Returning again to the areas of shadow, mix some Vandyke brown and cut masks for the shaded areas. These masks should be a little larger than the masks used earlier when the shadows were sprayed in black ink. The addition of Vandyke brown softens the shadows and makes them merge more realistically into the flesh tones of the legs and arms.

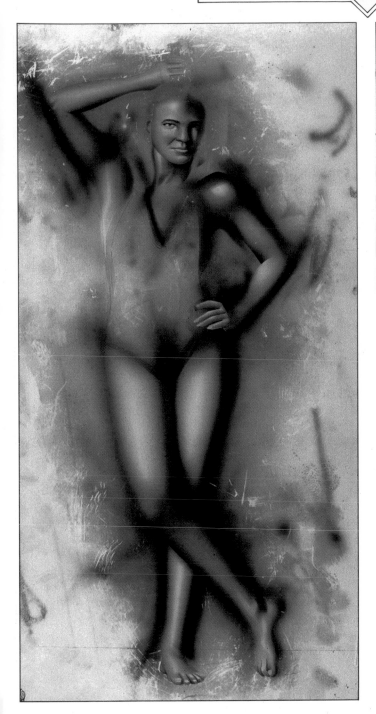

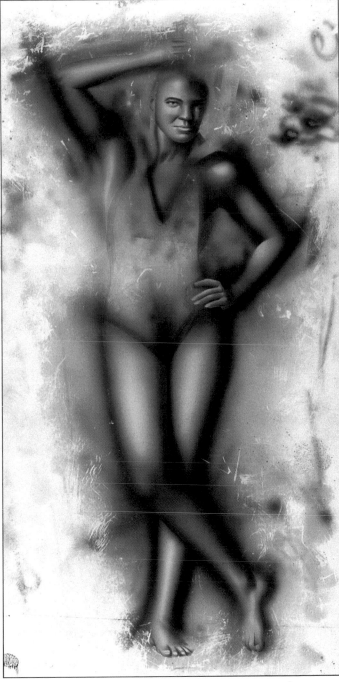

6 The process of giving volume and form to the figure is now taken one stage further. In order to refine the highlights, cut masks slightly smaller than those used before, and spray white gouache. The gentle contours that will be produced by progressively refining the shadows and highlights are particularly important for the girl's thighs and forearms, which need to appear smoothly curved.

7 The final artwork will show a sun-tanned girl, so it is important to correct the skin tones to give this impression. A mixture of burnt sienna and cadmium orange gives a tanned look. Spray a light coat all over the arms and legs, then cut masks for the areas where the shadows fall so that these parts can be given an extra spray to emphasize their darkness.

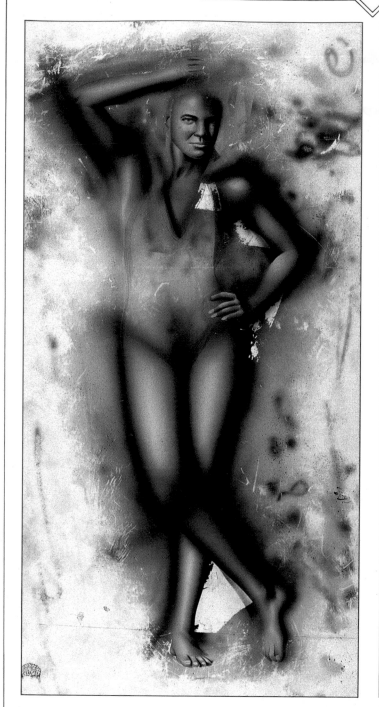

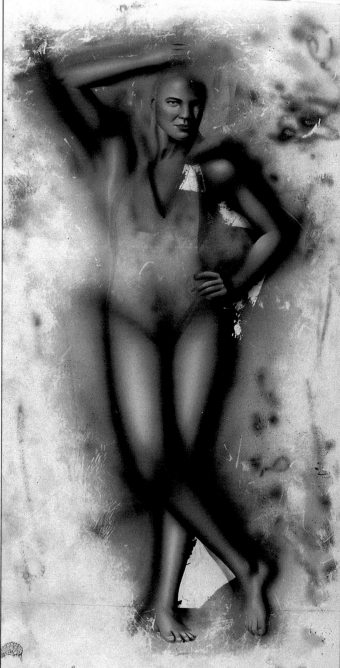

8 *A darker colour is now required to make the darkest areas of shadow appear sharper. Mixing ivory black with Vandyke brown gives a suitable shade. This shade will strengthen the most distinct shadows, such as the line where the legs touch, the divisions between the fingers, and the hard edge of the ankle. Work on the shadows is now complete.*

9 *The overall effect of the colours used so far has been to produce an unnaturally brown look. This can now be modified by spraying all over the arms and legs with vermilion deep. Be careful to apply only a very light coat of this colour, or the impression of a suntan will become one of sunburn. Begin with the finest spray possible, then check the result before spraying any further.*

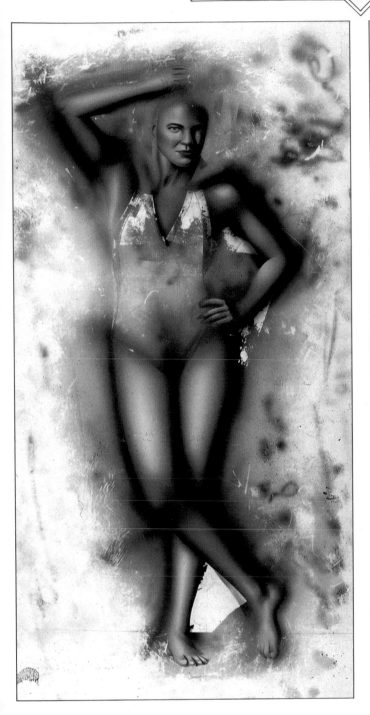

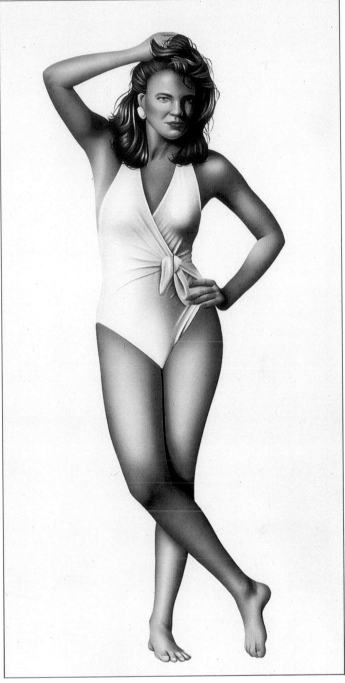

10 The final detail is now given to the highlights. Check with the original reference to see how prominent the finished highlights should be, then cut masks and spray white gouache to give each highlight a bright, central shape. Note that the highlights on the thighs are not perfectly regular — if they were the legs would look too cylindrical.

11 When you have taken the masking off the rest of the figure, you will be able to see whether any detail needs to be added to complete the artwork. In this example, the artist strengthened the line of shadow where the leg meets the bathing suit. Small details like this add greatly to the professional look of the finished image, more than repaying the effort involved.

Although a figure's arms and legs are rarely used as focal points, they nonetheless contribute to the final impact of an illustration and should not be neglected — particularly in the case of fashion or glamour work.

1 The success of this classic "pin-up" style hinges on the smooth treatment of the girl's legs. The whole support was masked to reveal only the arms and legs. Then, ink was sprayed freehand over the exposed areas, building up the colour with repeated passes of the airbrush. Highlights were created by rubbing back with an eraser.

2 The artist aimed to achieve a photorealistic style in this study of a ballerina. The whole illustration was airbrushed in ink. Careful shading of the highlights on the girl's legs enhances the degree of realism. Note also how the sense of perspective is increased by the slightly out of focus barre in the foreground.

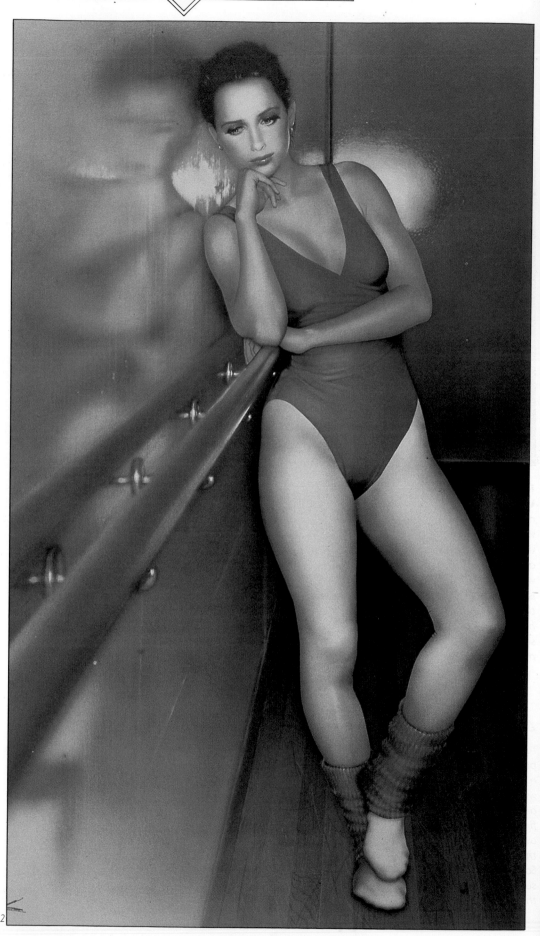

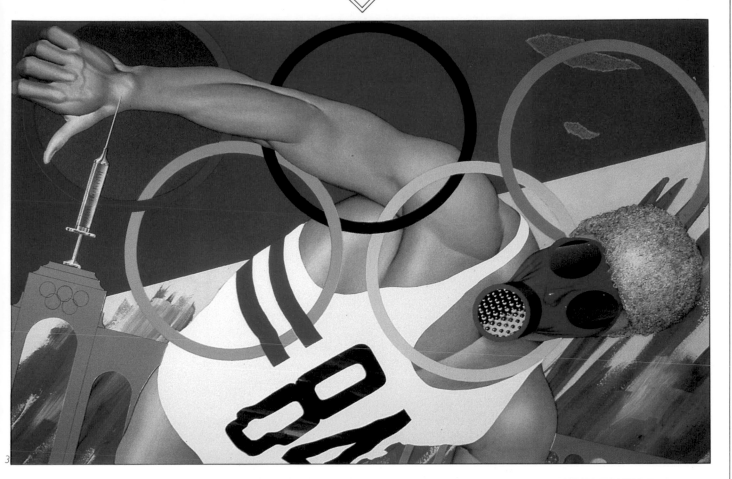

3 *The waves here were painted in acrylic — a waterproof medium which does not bleed when you spray over it. The artist then used watercolour for the arm and developed the detail with a sable brush. This artwork is a multimedia event in itself — the green disc in the swimmer's hand and his gold cap were separate pieces of paper montaged onto the support.*

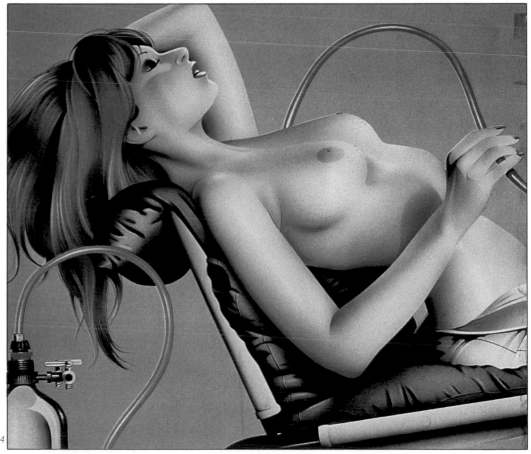

4 *The stylized look of this type of image allows the artist to take a few liberties. In this particular case, the arms are more nearly cylindrical than they would be in real life. The dark areas of the arms were sprayed first so that any accidental overspray could be covered when the lighter parts were airbrushed. Soft masks, held just above the support, give the soft edges that this style requires.*

CLOTHING

The type of clothing that the model wears is another important consideration. A relaxed mood can be enhanced by loose, casual clothing. On the other hand, a formal portrait of a captain of industry would depict him in his business suit, maybe sitting upright at the boardroom table. If the clothes in the artwork are very tight-fitting, you can draw the original reference as if it were an unclothed form and merely spray the colour of the clothes onto the same outline — some stylized advertisements for blue jeans have been created in this way. Loose-fitting clothes are best drawn from photographs or from real life. If you do not have reference that shows how particular fabric hangs and folds, it is easy to drape a piece of a comparable fabric into a similar shape to see how it behaves.

1 *Most of this artwork was airbrushed freehand — only the shirt was masked so that the stripes would not be spoiled by overspray. The coat was sprayed with a mixture of orange and blue transparent dyes, giving an almost brown shade of maroon. Note how the freehand use of the airbrush has given the overcoat a soft edge.*

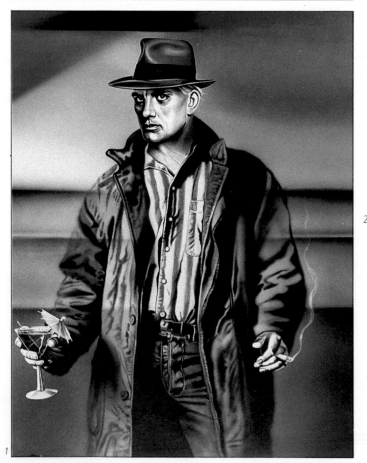

2 *The basic blue of the anorak was sprayed as a flat colour, and then the creases and folds were added. The smoother creases were added with a sable brush, but a combination of coloured pencil and sable brush was used for the sharper creases. The yellow stripes were sable-brushed in gouache — the opacity of gouache prevents the blue from showing through.*

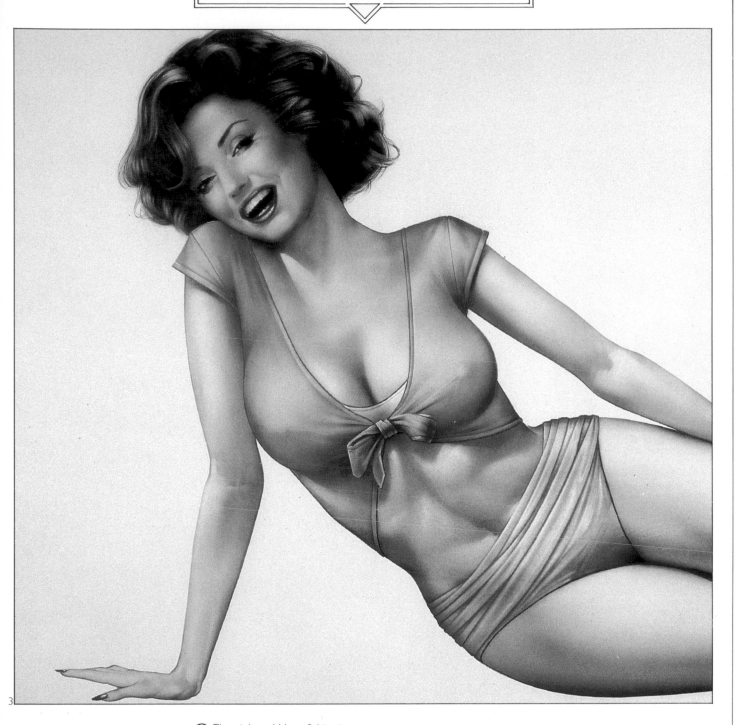

3 The pink and blue of this pin-up girl's clothing were laid down with an airbrush. All of the gradations of tone were also created by airbrushing, but the details such as the lines across the hips and the knot in the front of the blouse were added with pencil and crayons. The absence of any background focuses all attention on the girl herself.

1 David Bowie's trousers were airbrushed in diluted ink against a hard mask. The mask was held slightly offset to create the white line which is just visible along the trouser leg. The highlights were created by rubbing with an eraser — bear in mind that transparent ink is easier to erase than waterproof ink. All of the creases in the trousers were airbrushed freehand.

2 The "old-fashioned" look that the artist wanted to convey in this image meant that all of the edges and creases of the coat had to be sharp. He therefore masked all of the folds and outlines and airbrushed over the whole area of the coat. Freehand airbrushing would have given a softer feel, more appropriate to an up-to-date image.

3 A flat spray of watercolour was airbrushed to give the basic pink for the shirt and yellow for the trousers. Then, the detail was developed with coloured pencils. Water-soluble coloured pencils can give a wide range of effects: used dry, they produce a hard edge; moistening them in water allows you to create a softer line like the edge of the shadow underneath the shirt sleeve.

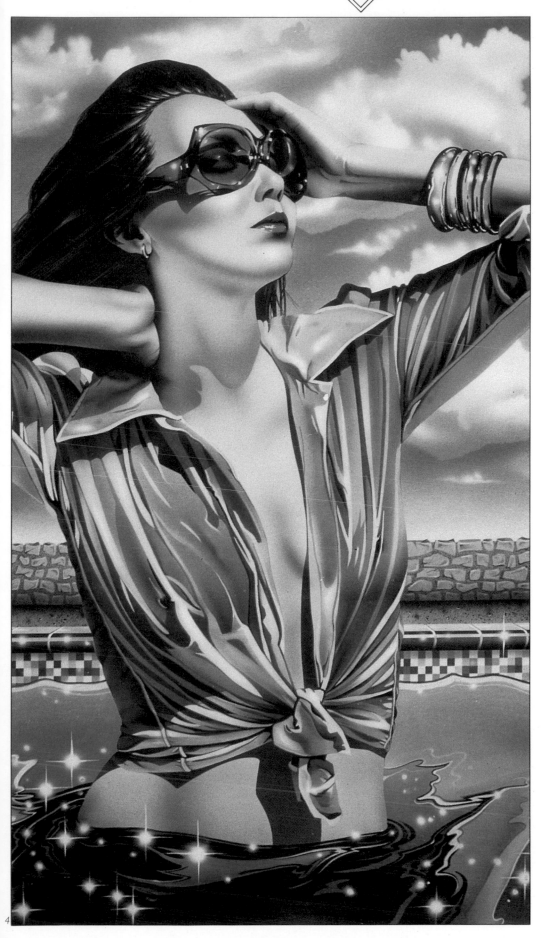

4 *The original photographic reference for this example was adapted to make the outline of the blouse smoother and sleeker. Much of the detail in the blouse was sable-brushed in gouache, but the overall effect was softened by airbrushing over the brushwork, masking each area in turn. Finally, the shadows around the blouse were added to heighten the solid three-dimensional impression.*

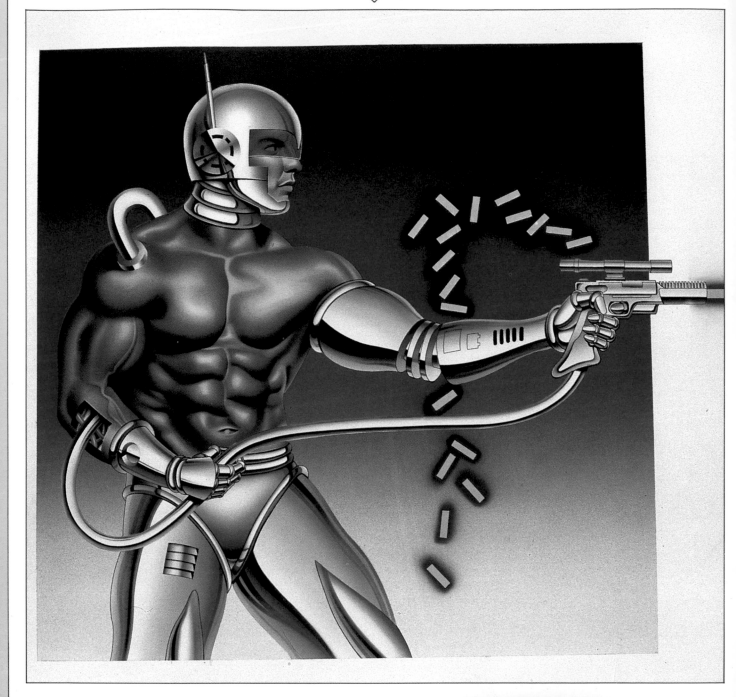

CHROME MAN

Melvyn Bagshaw has become well known for his slightly surreal, muscular, figures. His Chrome Man shows how, by using basic references combined with a creative imagination, you can create a unique artwork. When you are deciding on the theme for your artwork, it is always helpful to look at as many ideas as possible. Once Melvyn narrowed the field down to the concept of a muscular figure holding a gun, various specialist magazines provided photographic references which gave him an idea of the range of poses suitable for the Chrome Man. The photograph provided the basic stance that the Chrome man would adopt. The body-builder's muscles are already so well defined that his torso and thighs could be traced and used as a final reference for the finished artwork. The stance suggests aggression and lends itself well to the addition of a gun held by the outstretched arm.

1 The detailed drawing follows the photographic reference closely. All the contours of the muscles are indicated by pencil outlines. At this stage, the original reference is adapted so that the body-builder becomes the Chrome Man. The gun, helmet and chrome limbs are drawn in, as well as the wires protruding from the arms and the cascade of rectangles pouring from the gun.

2 The Chrome Man really takes on his own identity when the tonal sketch is completed. By shading in all the areas shown in the contour drawing Melvyn brings the figure to life. At this stage he can also check that the contours of the muscles look correct; if they do not it is easy to make any amendments to the drawing by erasing any parts which need to be changed.

3 You can now begin to create the chrome. Mask the whole board and reveal only those areas that will appear as chrome. The first colour to be applied is light blue ink. The realism of the chrome effect depends on the interplay of light and dark shapes which give the impression of reflections, so it is important to mask and spray accurately around key reflective areas such as the left elbow.

4 Having established the light areas, the darker shades on the chrome parts must be painted. This will help the lighter areas to stand out and give them their reflective appearance. Using a mixture of dark blue and black ink, darken those areas of the chrome that appear to be in shadow.

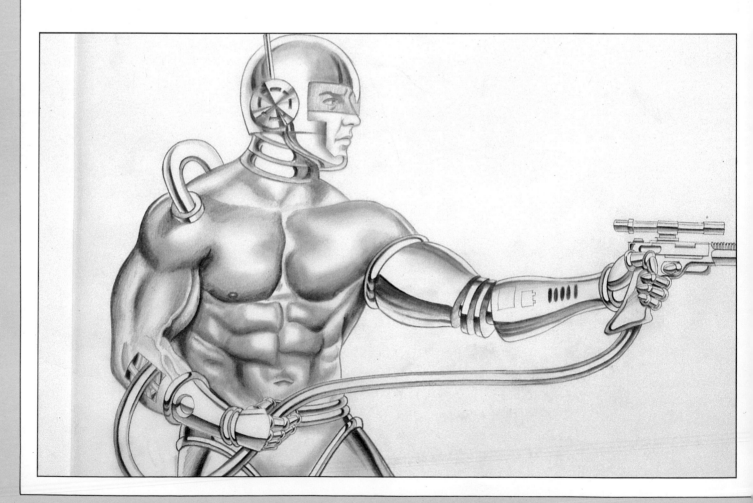

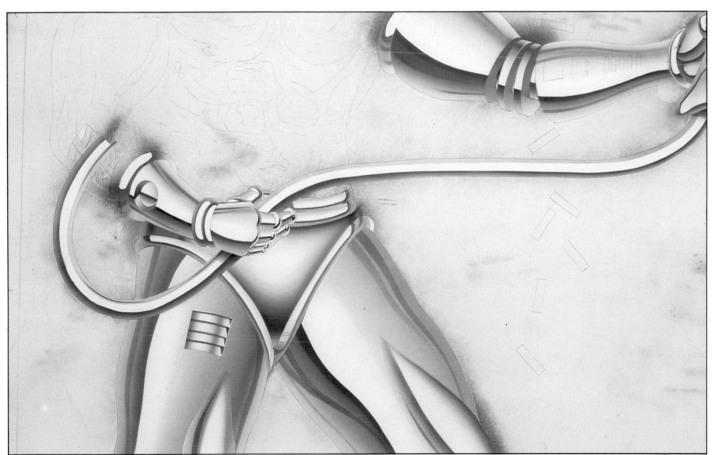

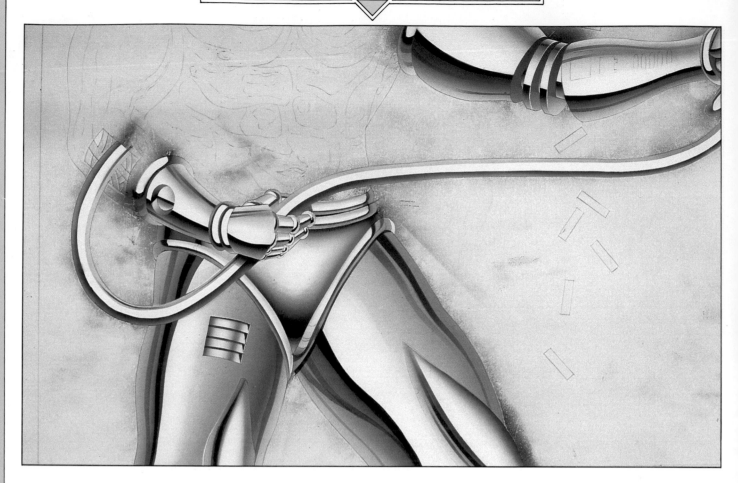

5 Taking the same principle one stage further, use black ink to intensify the darkest parts of the chrome. The hard black edges of the thighs add power to the whole figure, and the black areas on the underside of the outstretched arm make the chrome appear more vivid. Even without the colour contrast provided by the brown torso, the chrome parts will now begin to develop a metallic look.

6 A final application of black ink around the hard edges of the chrome adds definition, completing the metallic effect. At this stage put in the pure black detail of the slots in the outstretched arm and sharpen the edge of the cable running from the gun by intensifying the black along its lower side.

7 Small details such as the reflections of the yellow rectangles in the chrome will add greatly to the interest of the whole figure. A light application of orange around the edges of the arm and legs will not soften the metallic effect because our eyes interpret these colours as reflections in the surface of the chrome.

8 While the torso is still masked, add the last details – the coloured wires in the arm, the yellow rectangles and the beam from the gun. The bright colours make the final artwork more interesting, but the choice of colour is completely open because details like these are not intended to be realistic.

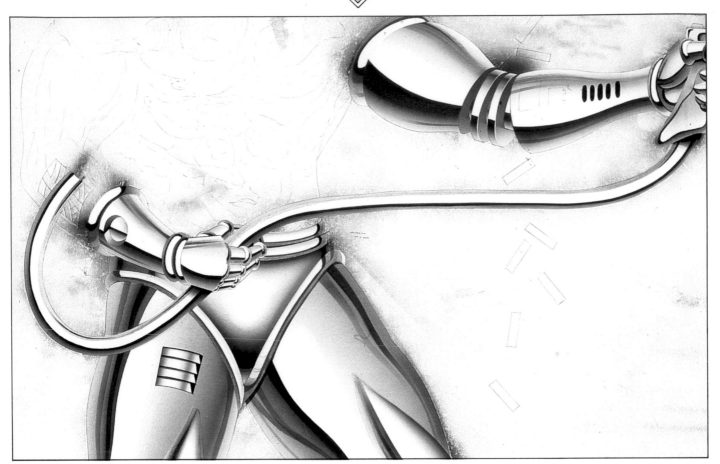

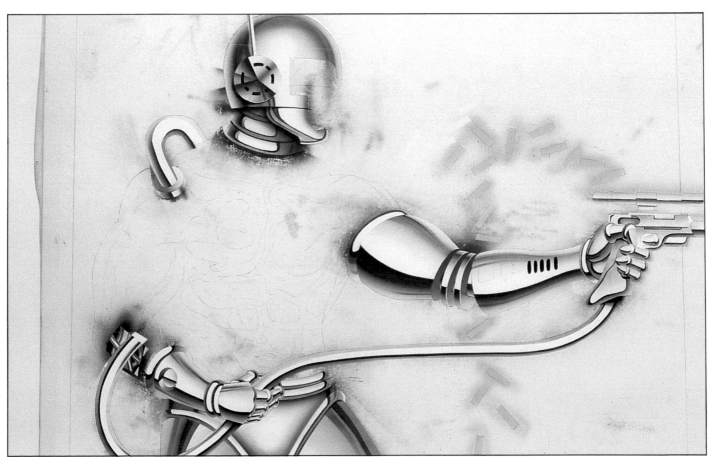

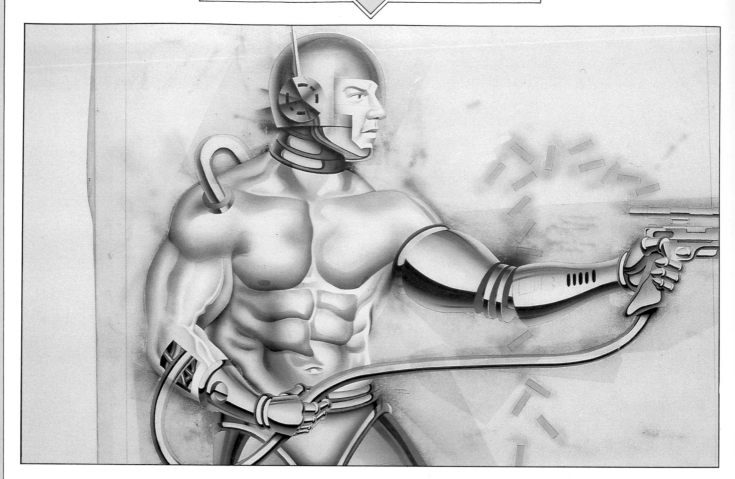

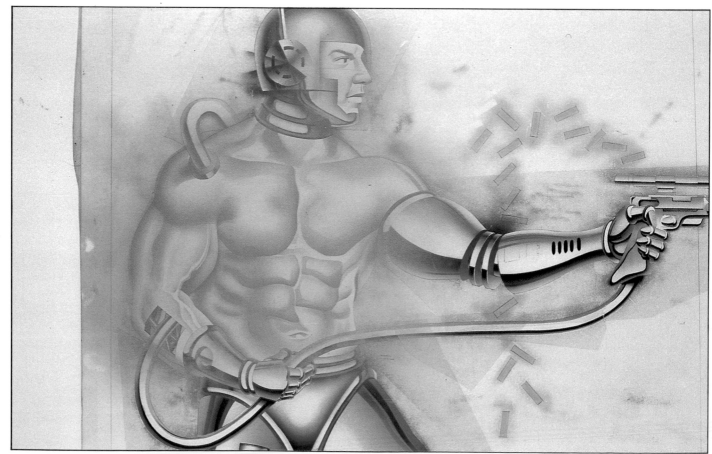

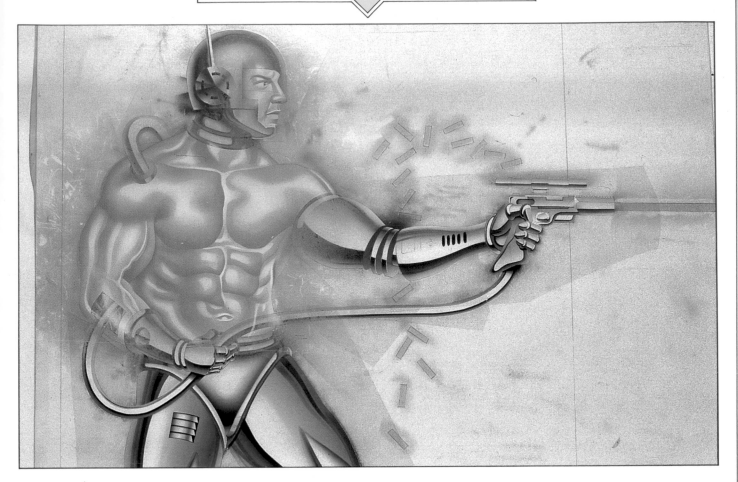

9 At this point remask the chrome area with new masking and reveal the torso. Use light grey ink to build up the shape of the muscles, spraying against masks held down flat to achieve a hard edge, or slightly above the board for the softer areas. Build up the light grey shade to give the torso greater solidity and volume.

10 Spray the torso with flesh-tinted poster colour, but apply the colour lightly and evenly so that you achieve a pink flesh colour, with the grey base still showing through the flesh. This creates the basic flesh tone, which will be refined later with highlights to bring the whole torso to life.

11 To create the highlights, cut masks which are slightly larger than the final size of the highlights, because the colour will be built up towards a bright central highlight. Spray white gouache, holding the masks just above the board so that the edge around the highlights is not too sharp.

12 In order to reduce the intensity of the white highlights, spray over the torso again with flesh-tinted poster colour. Apply the colour sparingly, checking all the time that the white highlights can still be seen through the new layer of flesh colour. The effect should be that the white appears as a brighter flesh tone.

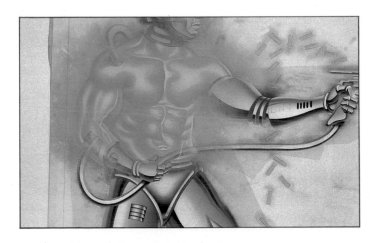

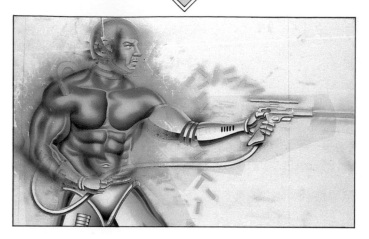

13 The torso now begins to develop its look of power but the muscles need greater definition. Using acetate masks, spray Vandyke brown gouache in the shadow areas. Again, where a sharply defined line is needed, hold the mask down firmly to the board. Build up the intensity of colour in the darkest areas, such as around the large chest muscles.

14 You can now return to the white highlights on the torso and face. Cut the acetate masks slightly smaller than those that were used for the previous highlights, so that the brightness of the white will increase gradually towards the centre of the highlight. These highlights will make the individual muscles more prominent.

15 Mix cadmium orange and burnt sienna in a proportion of two parts of orange to one part of burnt sienna. Cut masks slightly larger than the darker areas so that, when the new colour is sprayed, the dark brown in the centre of these areas tapers away to an orange-pink shade at the edge.

16 Using a mixture of Vandyke brown and ivory black gouache add the dark brown tones to the artwork. Check with your original reference material to see where the darkest shadows fall, and spray the dark brown shade carefully, checking constantly that the resulting shadow is not becoming too dark.

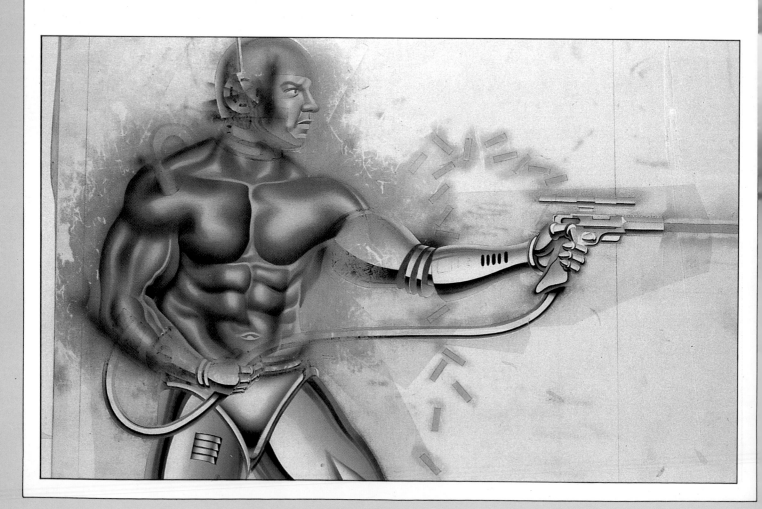

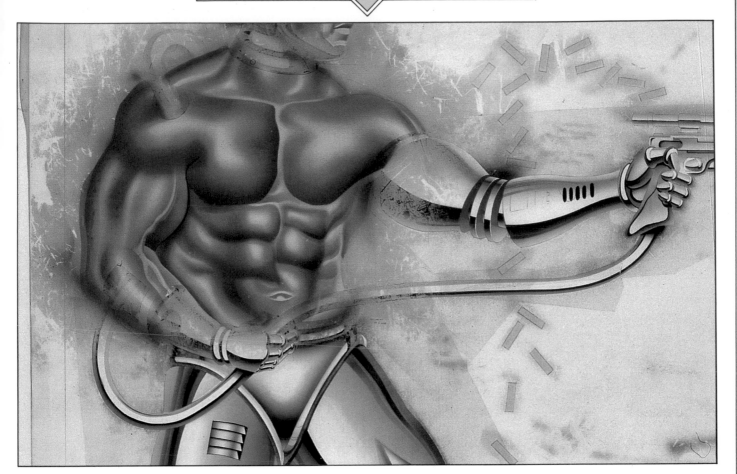

17 Intensify the shadows further with a darker version of the same colour, mixed from two parts of ivory black to one part of Vandyke brown. Apply this new colour to only the darkest areas of the body, such as below the chest muscles, under the arms and in the folds of the stomach muscles.

18 The final highlights can now be sprayed on the torso so that there is a central, clearly defined white area to give a rounded shape to the muscles. Remove all the masking and check that the result is what you set out to achieve.

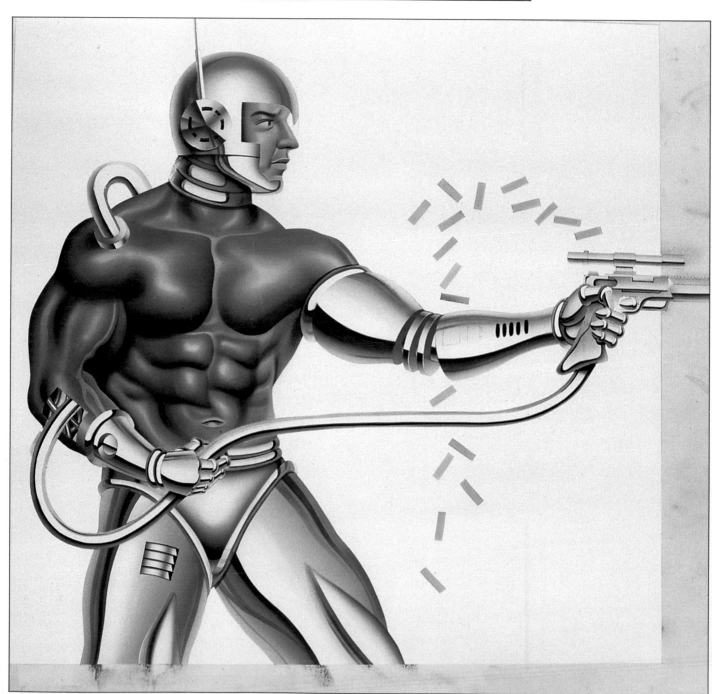

19 *Make any final adjustments to your work, and once you are satisfied with it, remask it and add the final colour and details to the background. In this case, the Chrome Man takes on an additional science-fiction quality when he is set against a background which suggests the sky.*

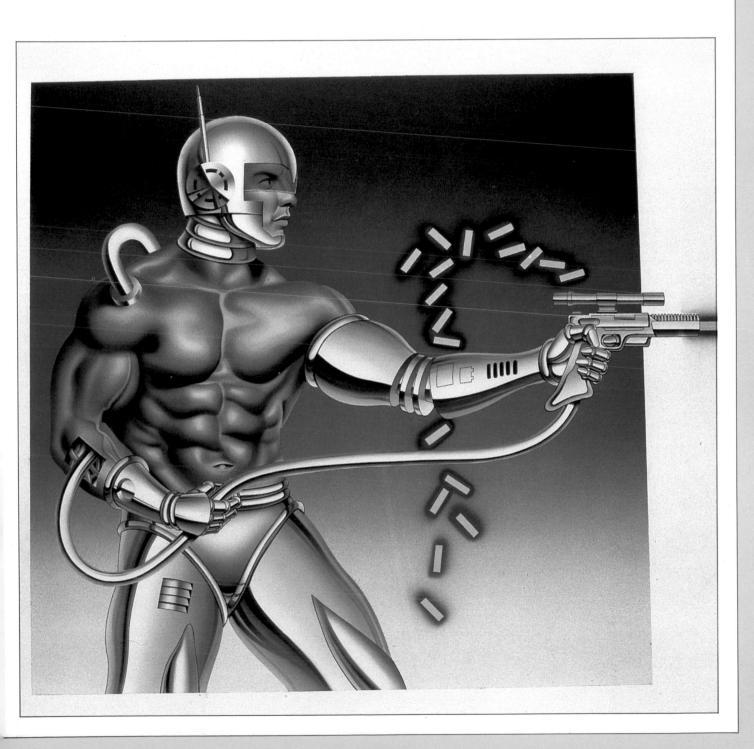

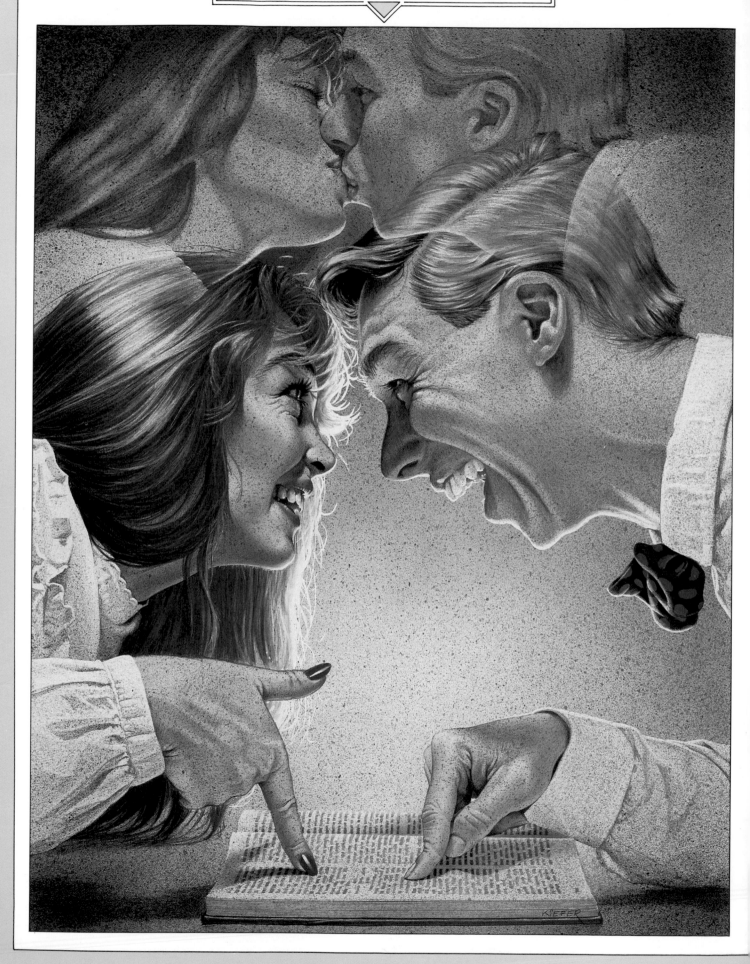

THE GALLERY

WILLIAM GRANDISON

PETER CLARK

JERRY OTT

DAVID BULL

TODD SCHORR

MICK BROWNFIELD

ALFONS KIEFER

-W·S·GRANDISON-

WILLIAM GRANDISON

William Grandison studied at Edinburgh Art College, and then worked as a graphic designer. He left this kind of work in order to concentrate on developing a career in illustration. Although he lives in Glasgow, William's agent is based in London, which means he can work from a studio in his own home without losing the opportunity of working for London's top art directors.

Among the influences which have shaped William's own style are nostalgia in general and older Americana in particular. The visual imagery which is found in films of the Bogart era can be detected in William Grandison's artworks, making them especially suitable for use as posters. The three images shown here were created for a poster company.

◀ *William Grandison gave the sailor's clothing opposite its luminous quality by first sable-brushing it in white, then softening the folds and creases with an airbrush. The underlying colour of the girl's dress was sprayed, the pattern being sable-brushed in gouache. Note how the overhead light source makes the girl's hair appear to be almost pure white in places.*

▲ *The Art Deco illustration shown here was sprayed in gouache. The stepped lines around the girl's body and in the background shapes are all slightly different in form, and so an individual mask had to be cut for each line. Some of the highlights were added in pencil, and the figure of the accordionist was sable-brushed.*

▶ *An interesting aspect of the artwork overleaf is the way that the light casts different kinds of shadows on hair and on skin. The shadows in the hair were pencilled, emphasizing the way the hair falls in strands, whereas the shadows on the legs were sprayed. Some details in the face were first pencilled, then sprayed over to soften the effect.*

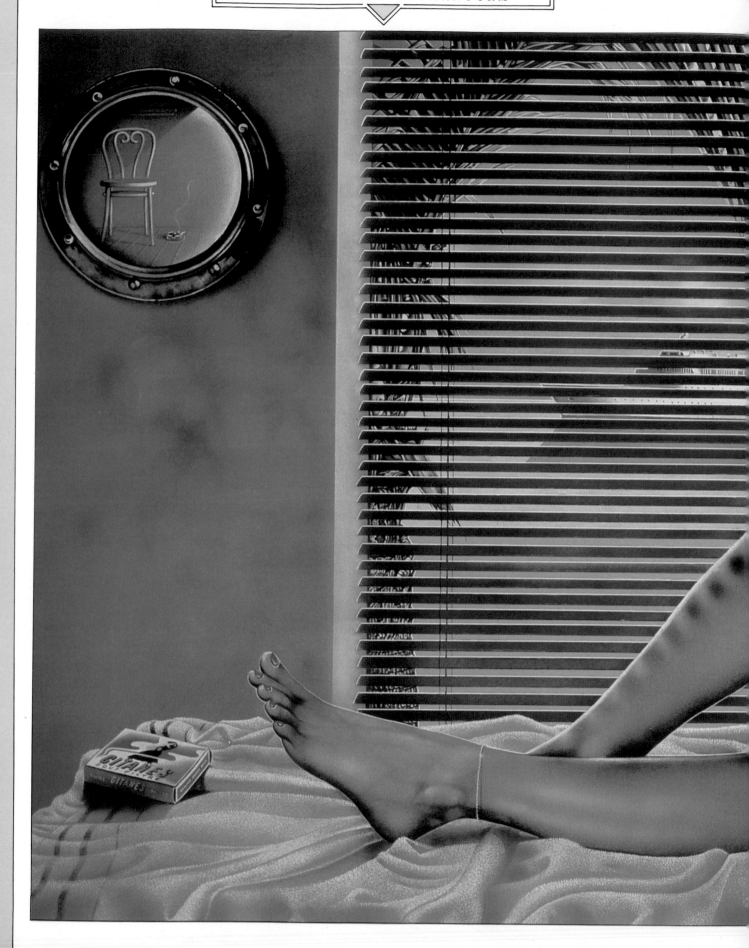

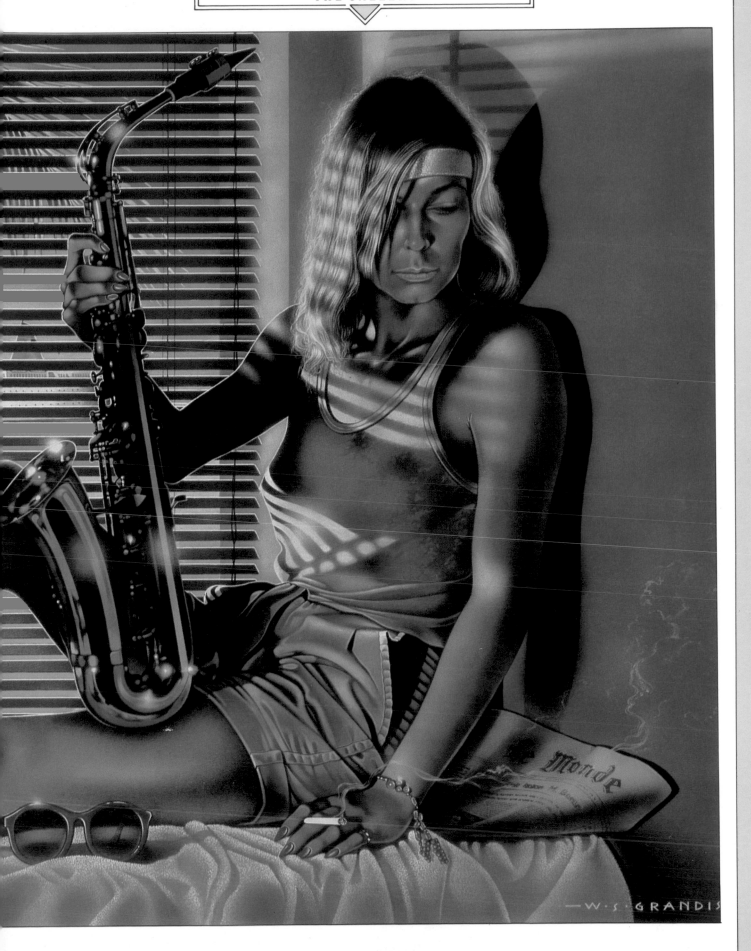

PETER CLARK

Peter Clark studied art in Manchester, then travelled south to London to work freelance. He worked on graphics for an English television company before moving to Los Angeles where he was involved in various artistic fields, including animation. Peter then worked as an illustrator in Amsterdam, subsequently returning to London where he is now based.

Over the years, he has used the airbrush to an increasing extent, mixing airbrushing with pencil, pastel and watercolour. At present, his work appears frequently in magazines published in Holland and Germany. In Britain, Peter Clark is regularly commissioned by advertising agencies and design groups.

▲This artwork shows how spatter can be used effectively in airbrushing. The black background and the beams of light have the characteristic appearance of spatter (this can be achieved either by running the airbrush at low pressure or by fitting a spatter cap). The "audience" in the purple areas were sable-brushed in watercolour and gouache.

▲Peter Clark used a flat spray of ink for the dress and then sable-brushed the red lines on the dress as well as the detail of the cape. The stonework of the buildings is a good example of spatter. For the lettering in the foreground, Peter used one mask for all of the red areas, and then cut a separate mask for the remaining yellow shapes.

▶In the example opposite, the repeated shapes in the background were sprayed against the same masks, which were moved round into a number of different positions. The face and hair are a mixture of airbrushed ink and sable-brushed gouache. There are some pencil lines in the hair; the straight red lines were drawn with pencil and ruler. Note the faint red spatter in the background.

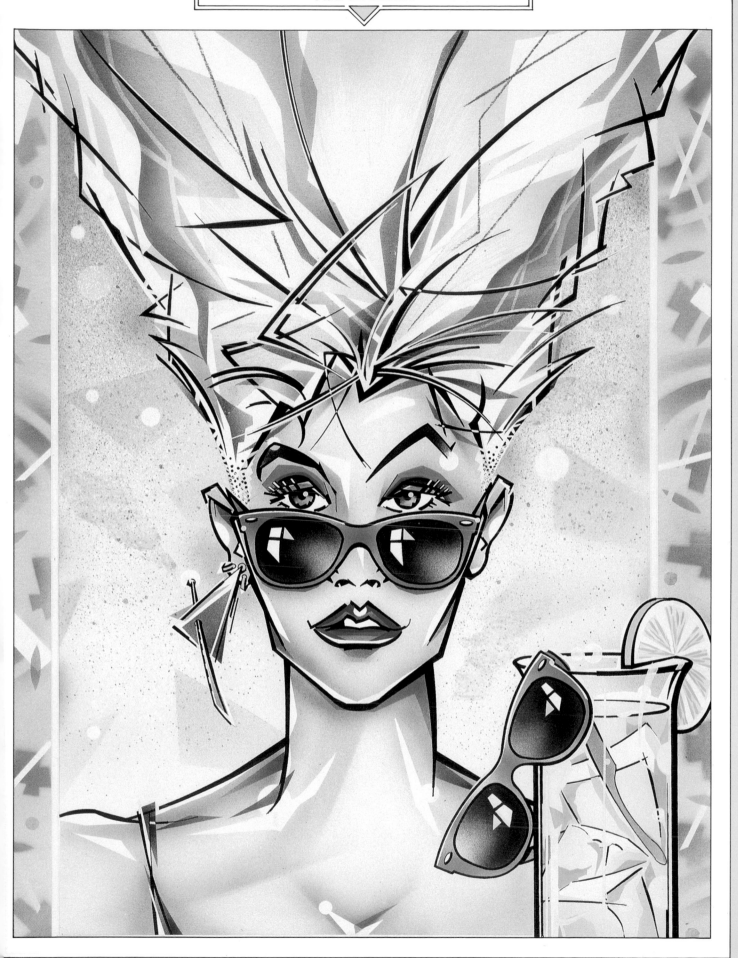

JERRY OTT

Jerry Ott began airbrushing in the late 1960s, when airbrushing was less popular than it is today. He had seen the work of Paul Wunderlich and decided to start creating his own figures, aiming for a realistic style. He exhibited his work in a New York Gallery during the 1970s and early 1980s. Jerry does not work as an illustrator but prefers to sell original works.

The remarkable feature of his artworks is their size. The figures in these two examples are approximately life-size. Jerry favours large-scale work because it adds visual impact. Unsurprisingly airbrushing such large areas is very time-consuming - each of the two artworks shown here took around a hundred hours of work.

▶Every detail of this illustration was airbrushed. All of the airbrushing was carried out freehand, without any kind of masking. Jerry works from photographic references and then transfers the image onto the board by using a grid system. When Jerry airbrushes, the board is vertical but the quick-drying qualities of the acrylic that he uses prevents the colours from running.

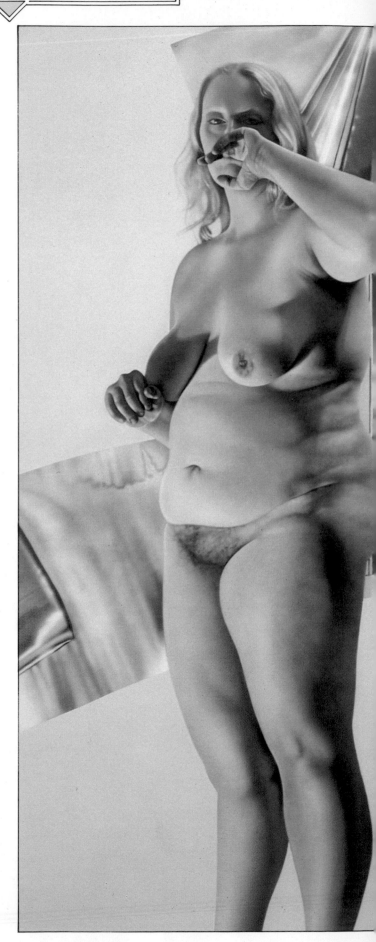

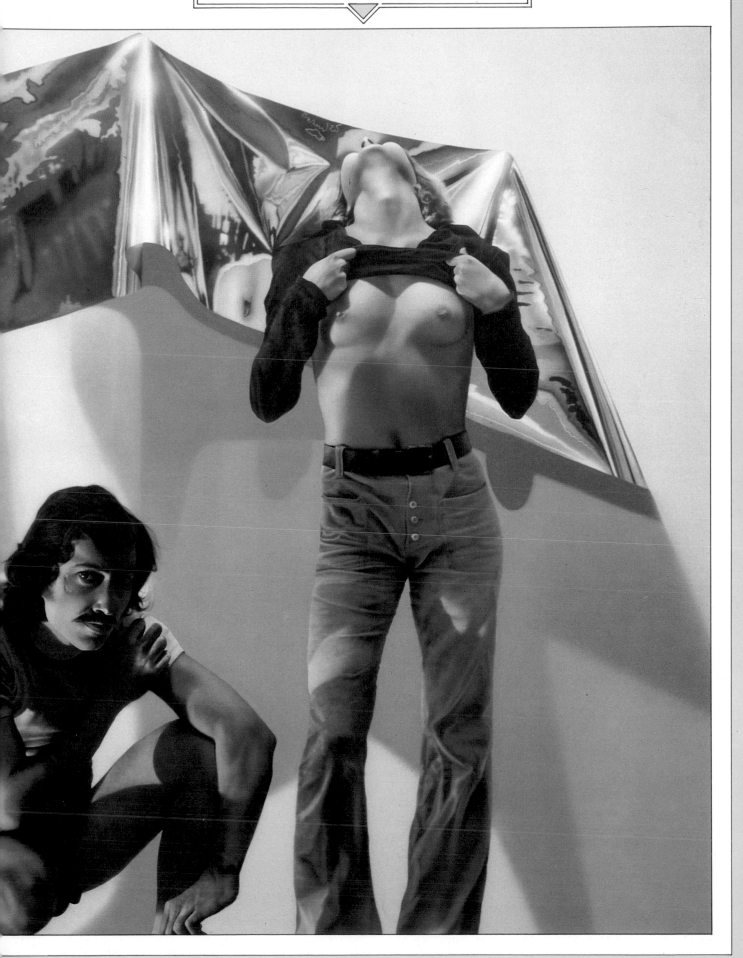

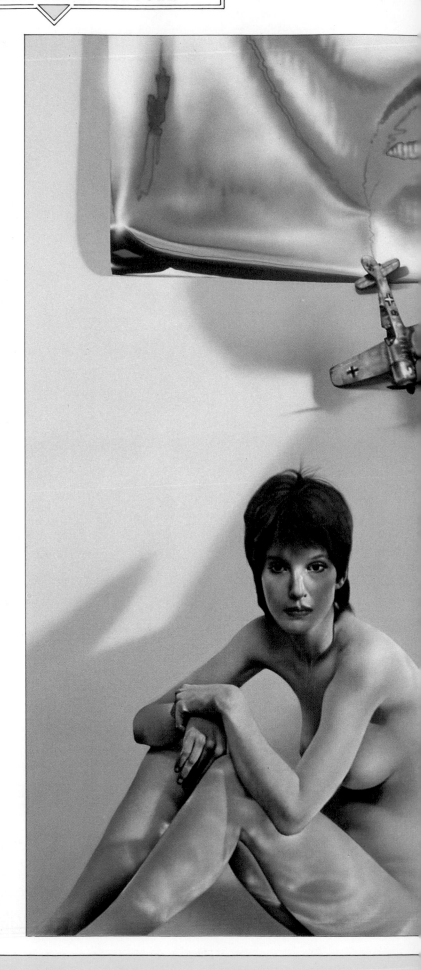

All of the colour in this example
was sprayed with a Paasche V-1.
By holding the needle well back,
Jerry can fairly rapidly block in the
background colour on a large
board . He gives the
skin a textured look by adding
pores for realism — this avoids
the classically smooth
"airbrushed" effect that many
artists favour.

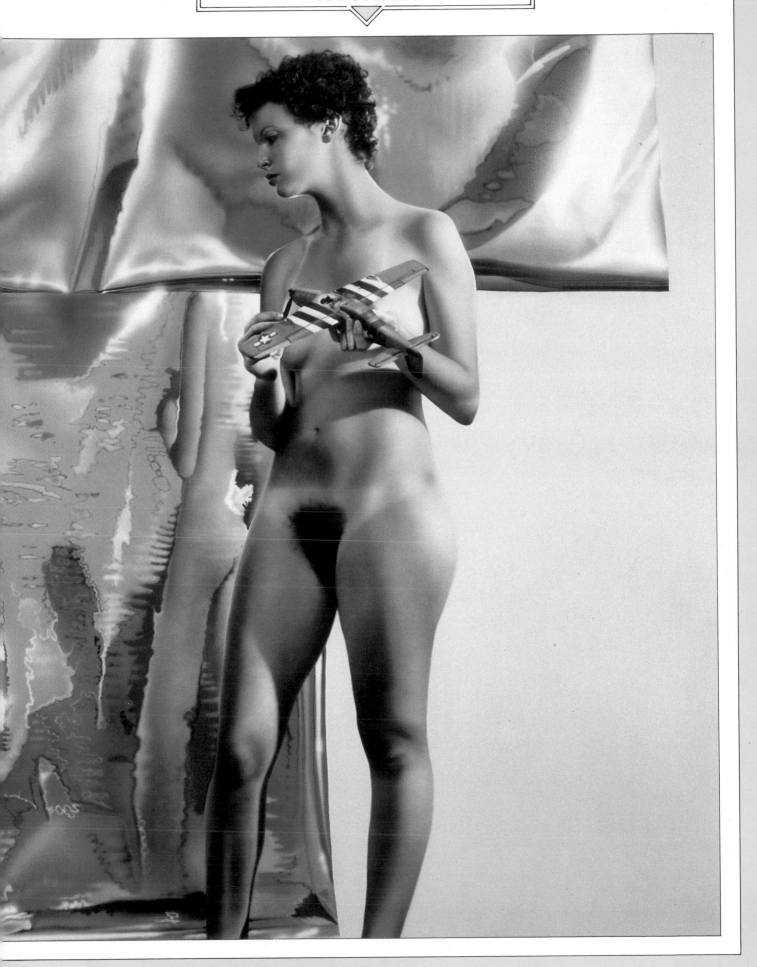

DAVID BULL

David Bull originally worked in an art studio, doing a variety of jobs before he took up the airbrush. As there was virtually no published information about airbrushing at the time, he is entirely self-taught. He became a freelance illustrator in the late 1960s after seeing an exhibition of work by the Pushpin group.

Since then, David has worked for major clients, including Barclay cigarettes, British Airways and Valvoline oil. As well as the artworks in this section, David has airbrushed a number of illustrations with a motor racing theme. He is a keen Grand Prix supporter and travels overseas to watch Formula One races whenever possible.

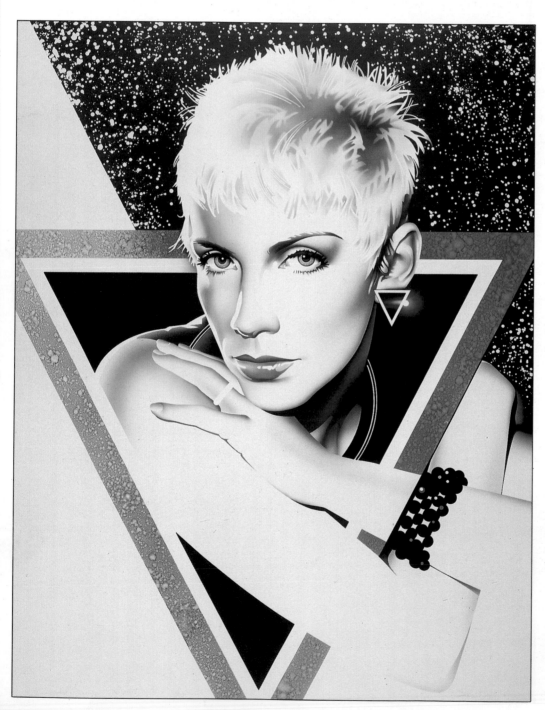

◄ This portrait of Annie Lennox was airbrushed in ink, using a spatter effect in the coloured triangle and in the black background. Some of the highlights in the hair were scratched out with a scalpel. Note the creative use of white space in this artwork: most of Annie's arms are left unpainted, but the viewer naturally fills in the missing details.

▶ David airbrushed this image for the book The Dead That Walk. He used ink throughout, then scratched out some of the highlights in Christopher Lee's hair. Much of the power of the illustration comes from the lighting; the cold light of the moon, shining on the monster's face from below, adds to the eerie mood of the scene.

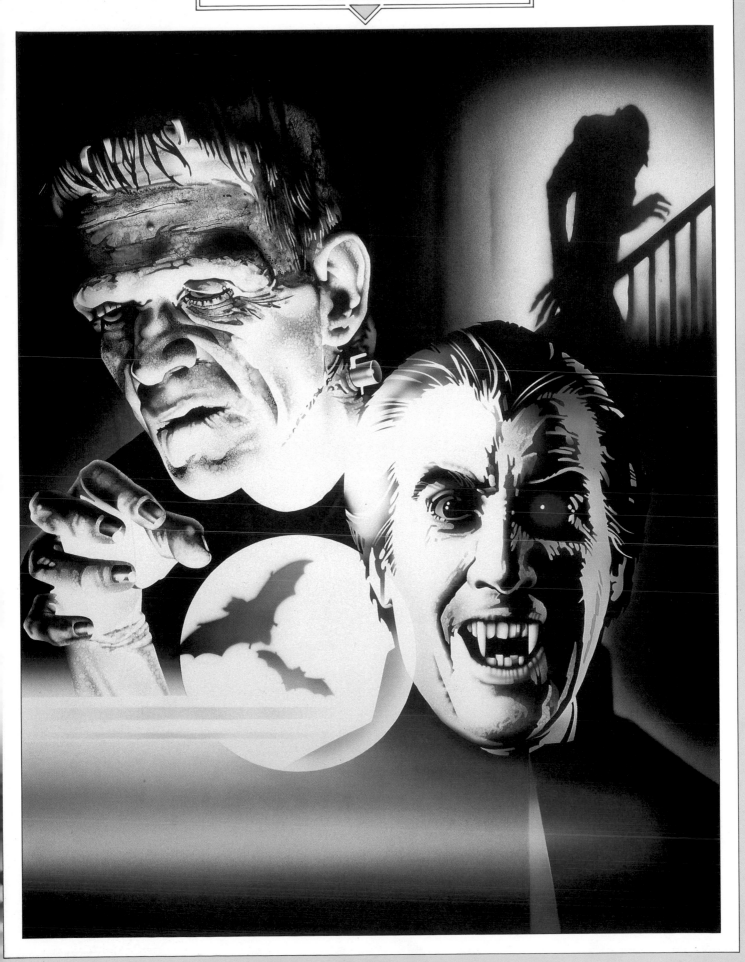

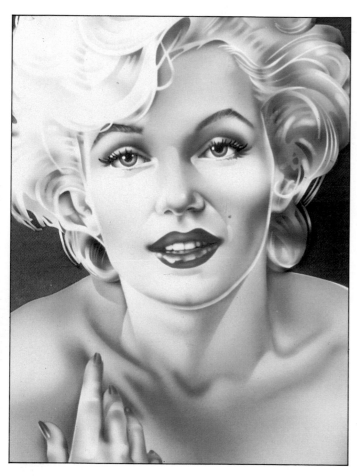

The Marilyn Monroe myth
remains enduringly powerful, and
this portrait was commissioned
for a Spanish cigarette
advertisement. The original
artwork was so large that David
first airbrushed the head,
shoulders and arms, then
montaged them onto the rest of
the illustration. The texture of the
dress was created by spraying
through netting.

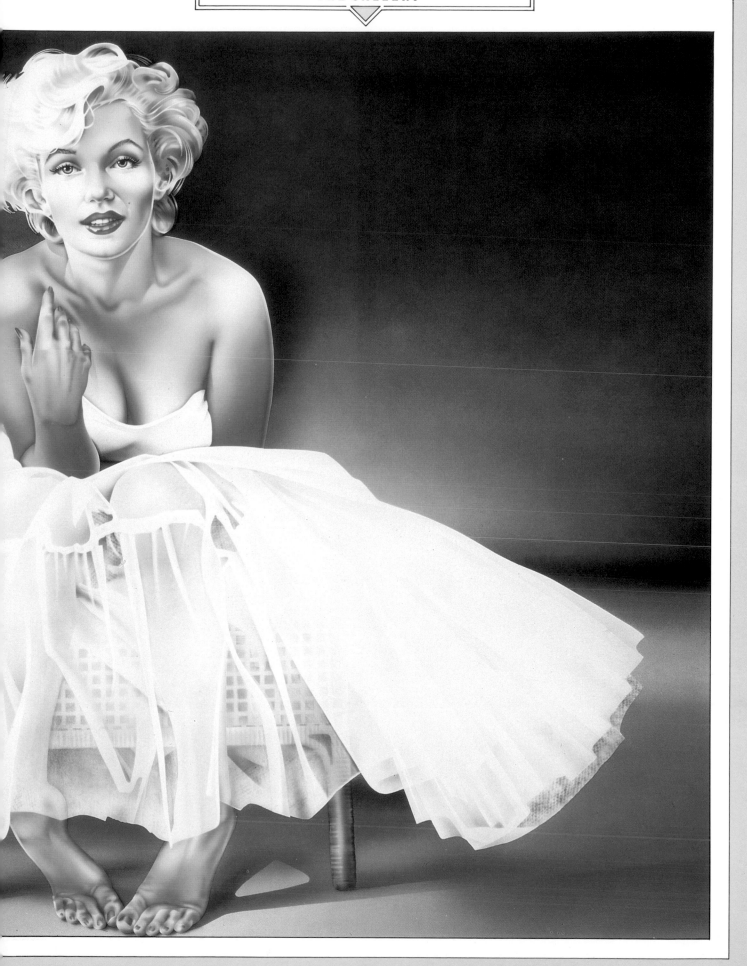

TODD SCHORR

Todd Schorr used to paint in oils before he learned to airbrush. In 1972 he met Charles White who explained the principles of airbrushing; there were not many books on airbrushing available at the time and so Todd learned by trial and error. While he was still attending the Philadelphia College of Art, Todd's work caught the eye of a New York agent, and commissions soon followed.

Among the styles that he admires, Todd numbers the older Walt Disney cartoonists, whose subject matter and imagery influenced his own work. There have been many highlights in Todd Schorr's career, including advertising work for Pepsi Cola, several Time magazine covers and album sleeves for major record labels including Atlantic and Columbia.

▲ Todd Schorr created this artwork for the cover of Bette Midler's novel The Saga of Baby Divine. The dark blue background was airbrushed onto a white board so that Todd could achieve the exact colour that he wanted. The lighter areas of the feather boa were sprayed in opaque paint to soften the effect of the underlying pink.

▶ When Todd airbrushed this portrait for Time magazine, he gave texture to the jacket by spraying at low pressure to produce a spatter effect. Then, he sprayed a smooth layer of colour over the spattering. The hair, in opaque gouache, and the flesh tones, in transparent dye, illustrate the different results that can be achieved with different media.

JULY 11, 1983 $1.75

TIME

THE COLOSSUS THAT WORKS
Big Is Bountiful at IBM

COMEDIAN EDDIE MURPHY
You Can Hear His
Audiences
Smiling

Chairman
John Opel

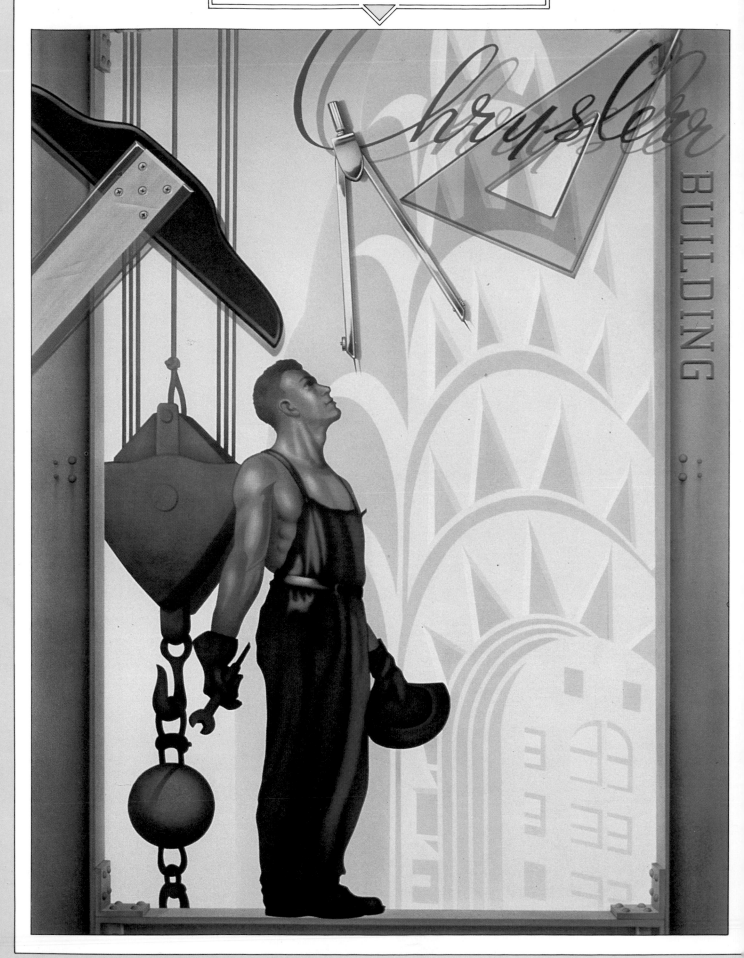

◀ A combination of transparent dyes and gouache was used in this illustration. Most of the image has been airbrushed, with some sable-brushing and use of coloured pencil for the details. The transparency of dyes makes their colours more difficult to correct: it is easier to make colour corrections with gouache, using its opacity to cover the colour underneath.

▲ Todd used transparent dyes for the skin tones and then sable-brushed the details in gouache. The background was also airbrushed in gouache. In order to create the swirling pink and green shapes in the foreground, Todd cut some acetate masks and moved them into different positions so that he could spray around and feather the edges of the coloured shapes.

▶ The detail overleaf from a Todd Schorr science-fiction scene was airbrushed in gouache. The larger areas were masked with frisket, whereas acetate was used to mask the smaller shapes. There is some sable-brushing in the creases of the trousers. The beam from the ray-gun was also sable-brushed, and then the edges of the beam were softened by airbrushing along them.

MICK BROWNFIELD

Mick Brownfield was born in London and studied at Hornsea Art college. After leaving college, he worked on promotional illustrations such as holiday brochures and architectural visualizations. Mick used an airbrush in this work and quickly learned the craft of airbrushing. he has been a freelance artist since 1973.

Mick was influenced by a number of American artists including Bob Zoell, but has developed his own "traditional" style. His work has been commissioned by many important clients including Guinness and The Sunday Times. In his rare moments away from the studio, Mick Brownfield likes to relax completely by going to the cinema.

◀ The inspiration for this image was an illustration by Ludwig Hohlwein, the German poster artist. Mick used a pen and black ink for the basic monochrome drawing, then sprayed flesh-coloured poster paint onto the arms and face. Further spraying with sepia ink added the darker *areas* of the flesh, giving the figure a feeling of solidity.

▲ It is possible to produce a monochrome image like this by starting with a black support and then spraying in white. However, in this picture of Max Bygraves, the support was white and the background was painted in black ink. A light spray of black gave the basic colour of the face. Mick used a sable brush and white gouache for the creases next to the eye.

This study shows how the airbrush artist can build up a picture from a large number of shapes. A similar result could have been obtained by making a montage of paper cut-outs. When work on the lips was complete, Mick masked the edges of the lips and sprayed the background in opaque gouache.

'82

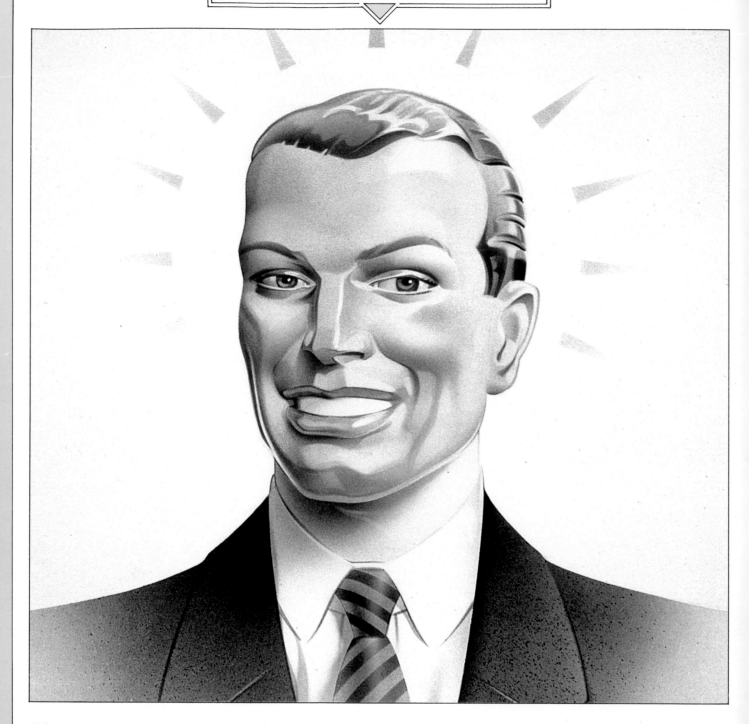

▲ For this artwork, Mick used acetate masks — he cut a separate mask for each part of the "halo" rather than using the same mask in different positions. Most of the details were sprayed in ink, but a sable brush was used for the highlights in the eyes. The head is intended to look as if it were made of china or plastic — note the "strip of celluloid" teeth.

▶ The Observer Magazine in London commissioned this portrait of Richard Branson. The basic flesh tones were airbrushed in gouache, then the details of the beard and moustache were added with pencil and sable brush. The highlights in the teeth were created by alternately spraying and sable-brushing, giving the natural-looking "shapes within shapes".

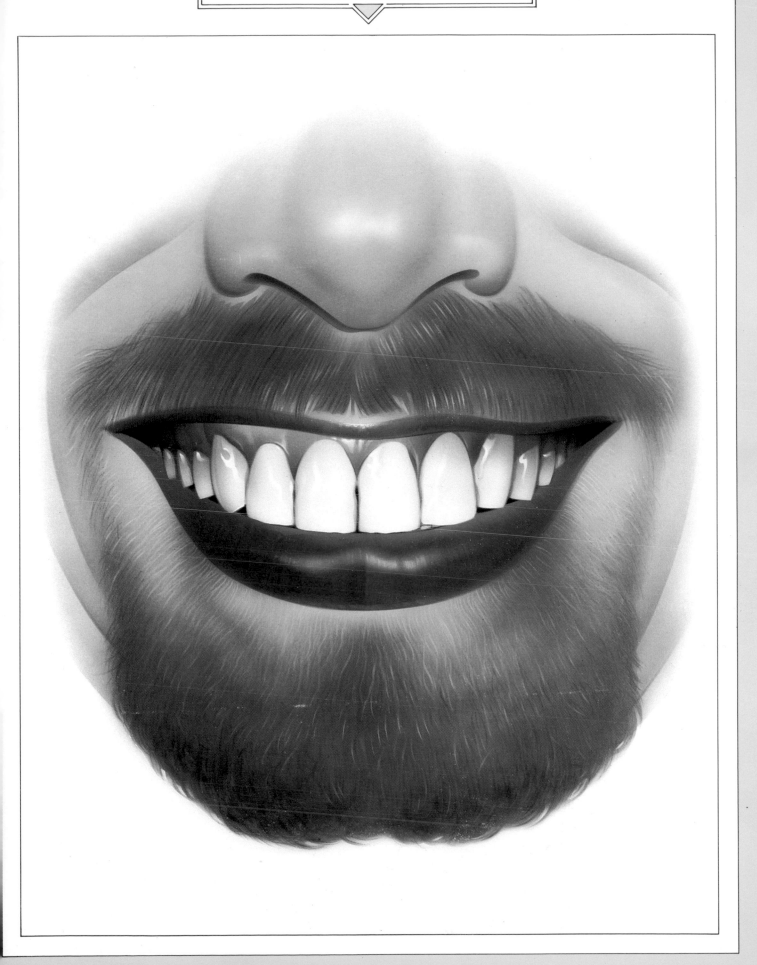

ALFONS KIEFER

Alfons Kiefer began airbrushing with a mouth diffuser. He later took up airbrushing proper, but still to this day uses a mouth diffuser to create backgrounds for his artworks. Alfons first studied art, then worked for two years in a Munich advertising agency. He has been freelance since 1981, accepting commissions from magazines and advertising agencies. Some of his work has a light-hearted touch, and he numbers Rockwell among the artists who have influenced him because he too liked to introduce a humorous element into his artworks.

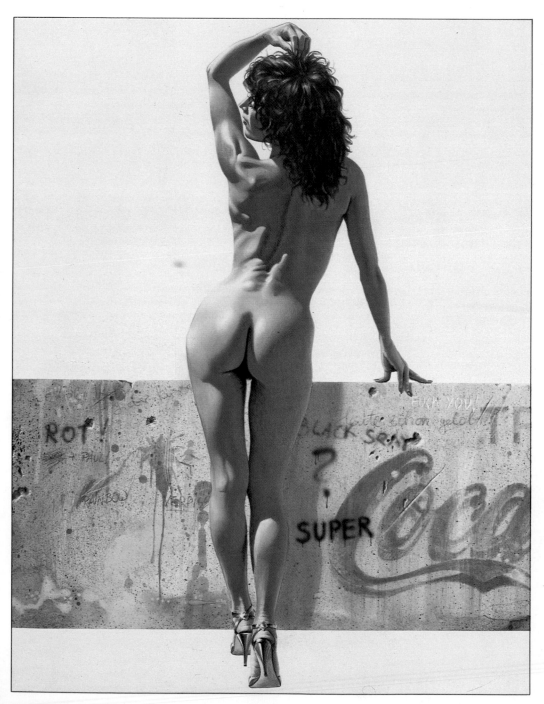

▶ This illustration was created for the German edition of Playboy magazine. The skin tones were airbrushed but the hair was painted with a sable brush. Both sable brush and pencil were used for the stripes on the jacket. Note the way that the blue of the jacket is reflected by the man's chin and by his eyes.

◀ Alfons created the original drawing for this illustration from a photographic reference. The skin tones contain a mixture of brown, orange and yellow watercolour, with the details added in pencil. He used a mouth diffuser to spray the coarse texture of the wall. Some of the graffiti on the wall was allowed to run so that it would appear more realistic.

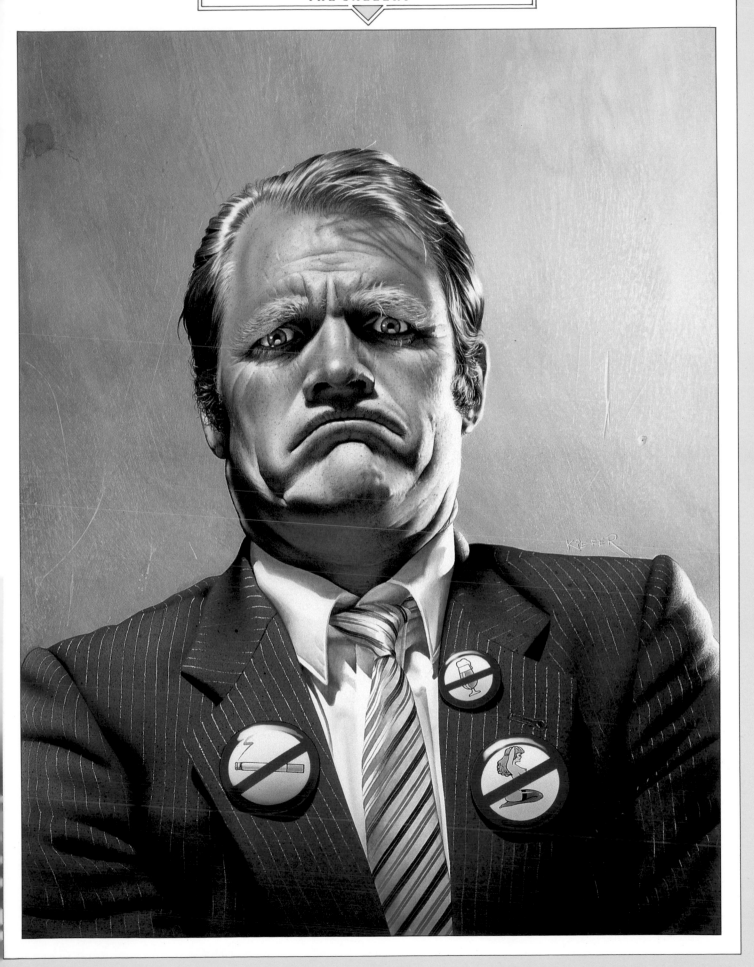

GLOSSARY

ABSORBENCY
The ability of a support to soak up any medium which is sprayed or brushed onto it. Unglazed paper tends to be more absorbent than paper which has a shiny surface.

ACETATE
Transparent plastic sheet, very often used in airbrushing. It can act as a mask, allowing the artist to position it accurately because he can see through it. Alternatively, acetate can provide a good support for airbrushing, particularly if the final artwork is to be projected by an overhead projector.

ACRYLIC
Type of medium made from a synthetic resin. Acrylic's quick-drying nature makes it ideal for large-scale artworks because the support can be held vertically and the acrylic will not run. Acrylic dries to form a very tough, waterproof coating.

ADAPTER
A coupling which enables an air hose to be connected to an airbrush for which it was not originally intended. Adapters are available for most airbrush/ air hose combinations.

AIR CAN
A canister of propellant which drives an airbrush. The propellant is usually carbon dioxide or Freon. An air can makes the airbrush fully portable, but is not economical if the airbrush is to be used for long periods.

AIR ERASER
An eraser which works on the same basic principle as the airbrush, but sprays abrasive particles instead of paint.

ARTWORK
Any finished product created by the artist. In studio parlance, an artwork would be of high quality, ready to sell to the client.

BLEEDING
The tendency of a colour to show through any colour sprayed on top of it. The manufacturer of the colour will usually state whether a colour bleeds.

BRISTOL BOARD
A kind of support which is popular with airbrush artists. A variety of thicknesses and qualities are available.

COLOUR CUP
The part of an airbrush into which the medium is poured. Airbrushes with top-mounted cups usually hold less medium than those which have cups on the side of the airbrush or underneath it.

COMPRESSOR
The machine which supplies air under pressure to the airbrush. Compressors range from simple devices intended for occasional use to expensive professional models.

CONSERVATION QUALITY PAPER
A top-quality paper which is

free of acids and other impurities which might damage the artwork. This grade of paper is very expensive to make.

DOUBLE ACTION AIRBRUSH
An airbrush in which the lever controls the flow of both the air and the medium. Most artists prefer the independent double action type, which allows the flow of air and the amount of medium to be controlled independently.

DRAWING PEN
A technical pen which uses a tube instead of a conventional nib. A number of different sizes of tube are available. The advantage of technical pens is that they can be used for drawing lines of constant width, as long as the pen is held vertically.

FORM GUIDE
A holder containing a large number of sliding teeth. When the teeth are pressed against a profile, they slide and take up the shape of the profile. Form guides enable the artist to copy a shape from a three-dimensional object and transfer it to paper.

FREEHAND
Any drawing or painting which does not use masking or other fixed guidelines. Many airbrush artists do some freehand work within the broad outline of a mask, but purely freehand airbrushing is rare.

FRENCH CURVES
Shaped templates which include curves of different radii. French curves are often sold in sets so that almost any kind of curve is included. They may be used as masks or for ruling curved lines.

FRISKET
A kind of masking film with an adhesive surface, designed to be laid down on the support and then cut to shape.

GOUACHE
A variety of watercolour to which fine particles of chalk have been added. Unlike watercolour, gouache is opaque, but it is still very suitable for airbrushing.

GRID
A pattern of squares ruled onto an original reference so that the same image can be transferred to the board on which it will be airbrushed. By varying the size of the squares on the reference and on the board, one can alter the scale of the image while keeping the proportions the same.

HARD MASKING
Any kind of masking which enables the artist to spray a sharply-defined line between one colour and the adjoining colour. Self-adhesive film and masking tape are examples of hard masking.

HIGHLIGHT
Usually the lightest-coloured part of the finished artwork, showing that light is being

reflected — eyes and teeth are often given highlights. The highlight may be sprayed, brushed or scratched out with a sharp edge.

INK
Type of medium often used by airbrush artists. The two main kinds are waterproof and non-waterproof. Inks are not available in as wide a variety of colours as gouaches and watercolours.

LIQUID MASKING
A rubber solution which is brushed onto the support and dries to form a mask. When it dries, liquid masking forms a continuous layer which can be cut and peeled away without damaging the surface. It is not advisable to use this form of masking if large areas need to be covered.

LOOSE MASKING
Any form of masking which is not firmly attached to the support. Paper is often used as a loose mask, as it can be held just above the support to give a soft edge.

MASKING FILM
Transparent self-adhesive film, widely used for masking. Once the backing has been peeled off, the film can be laid down on the support and then cut in place. It is designed to come away from the support without causing any damage because it has a low-tack adhesive.

MEDIUM
In airbrushing terminology, any kind of paint or colour which can be sprayed. Commonly-used media include watercolour, gouache, acrylic and ink.

MOISTURE TRAP
A useful airbrush accessory that removes moisture from the compressed air so that it will not contaminate the medium being sprayed. Some moisture traps are built into the compressor, but other types fit into the air hose between the compressor and the airbrush.

MOUTH DIFFUSER
The most basic kind of instrument using the airbrush principle. It consists of two tubes hinged together. One tube is dipped into the medium and the artist blows through the other tube, causing paint to be sucked up and sprayed.

OIL PAINT
A medium which has some disadvantages for airbrush work. Oils need to be thinned so that they can be sprayed, and take a long time to dry, making complicated artworks tedious to spray. On the plus side, oils are available in a very wide range of colours.

PANTOGRAPH
A device for transferring an image from the original reference. The pantograph consists of a number of levers which can be adjusted to vary

the degree of enlargement between the original image and the copy. Pantographs are useful alternatives to the grid system for transferring images.

REGULATOR
A feature of the more advanced compressor that allows the pressure supplied to the airbrush to be controlled. Regulators can be added to basic compressors, and are sometimes sold combined with a moisture trap. A greater range of airbrush effects can be created if the air pressure can be varied.

SABLE BRUSH
An artist's paintbrush with sable bristles. Most airbrush artists use sable brushes, particularly the finer sizes, for adding small details to their artworks.

SINGLE ACTION AIRBRUSH
A basic kind of airbrush in which the lever works as an 'on-off' switch, bringing in the flow of air and paint together. Many artists begin with single-action models, then progress to the double-action variety because of the extra control over paint and airflow that the double-action system provides.

SPATTER
An airbrushing effect which creates small droplets of paint on the paper instead of an even, atomised spray. Spatter can be created by lowering the pressure from the compressor,

or by removing the nozzle cap from the airbrush and fitting a spatter cap in its place.

SPRAY GUN
A large-scale airbrush which produces a wide spray. Some artists who create large artworks use a spray gun for blocking in the background, then change to an airbrush for the more detailed areas.

TACK
The degree of adhesion of a mask or support. Self-adhesive masking film is designed to have a low tack so that it can be peeled away after use without damaging the artwork underneath.

WATERCOLOUR
A popular airbrushing medium. Watercolours are sold in a wide range of shades and are available ready-diluted for airbrush use. They are transparent, allowing the colour to be built up progressively with repeated passes of the airbrush.

INDEX

CREDITS

p2 Alfons Kiefer. **p7** Alberto Vargas, courtesy of Esquire Associates © 1945. **p8** Mark Taylor (photography Paul Forrester). **p20** Melvyn Bagshaw. **p24** (right) Melvyn Bagshaw. **p25** Paul Forrester. **pp26-33** Melvyn Bagshaw. **pp34-37** Paul Forrester. **p38** Melvyn Bagshaw. **pp40-45** Mark Taylor. **pp46-47** (1) Bill Prosser, courtesy of Jacqui Figgis; (2) Mark Wilkinson, courtesy of Aircraft; (3) Peter Stallard, courtesy of Folio. **pp48-49** (1) Bill Prosser, courtesy of Jacqui Figgis; (2) Colin Elgie, courtesy of Jacqui Figgis; (3) Tom Stimpson, courtesy of Aircraft; (4) Ean Taylor, courtesy of Folio; (5) Bill Prosser, courtesy of Jacqui Figgis. **pp50-61** Melvyn Bagshaw. **pp62-63** Mark Taylor. **pp64-65** Ean Taylor, courtesy of Folio. **pp66-67** (1) Ean Taylor, courtesy of Folio; (2) Syd Brak, courtesy of Folio; (3) Mark Wilkinson, courtesy of Aircraft; (4) Todd Schorr; (5) Ean Taylor, courtesy of Folio. **pp68-69** (1) & (2) Ean Taylor, courtesy of Folio; (3) Bill Prosser, courtesy of Jacqui Figgis; (4) Syd Brak, courtesy of Folio; (5) Tom Stimpson, courtesy of Aircraft; (6) Bill Prosser, courtesy of Jacqui Figgis. **pp70-73** Mark Taylor. **pp74-75** (1) & (2) Ean Taylor, courtesy of Folio; (3) Peter Owen, courtesy of Jacqui Figgis; (4) Ean Taylor, courtesy of Folio. **pp76-77** (1) & (2) Mark Wilkinson, courtesy of Aircraft; (3) Peter Stallard, courtesy of Folio. **pp78-81** Mark Taylor. **pp82-83** Tom Stimpson, courtesy of Aircraft. **pp84-85** (1) Syd Brak, courtesy of Folio; (2) Graham White, courtesy of Folio; (3) Geoff Nicholson, courtesy of Ian Fleming & Associates; (4) Bill Prosser, courtesy of Jacqui Figgis. **pp86-91** Melvyn Bagshaw. **pp92-93** (1) Ean Taylor, courtesy of Folio; (2) Syd Brak, courtesy of Folio; (3) Bill Prosser, courtesy of Jacqui Figgis; (4) Ean Taylor, courtesy of Folio. **p94** (1) Mark Wilkinson, courtesy of Aircraft; (2) Bill Prosser, courtesy of Jacqui Figgis. **p95** Syd Brak, courtesy of Folio. **p96** (1) Mark Wilkinson, courtesy of Aircraft; (2) Syd Brak, courtesy of Folio; (3) Bill Prosser, courtesy of Jacqui Figgis. **p97** Ean Taylor, courtesy of Folio. **pp98-109** Melvyn Bagshaw. **p110** Alfons Kiefer. **pp112-115** William Grandison, courtesy of Ian Fleming & Associates. **pp116-117** Peter Clark. **pp118-121** Jerry Ott. **pp122-125** Dave Bull. **pp126-131** Todd Schorr. **pp132-137** Mick Brownfield. **pp138-139** Alfons Kiefer.